# 1960S SOUTHERN REGION STEAM IN COLOUR

George Woods

AMBERLEY

First published 2017

Amberley Publishing
The Hill, Stroud
Gloucestershire, GL5 4EP

www.amberley-books.com

Copyright © George Woods, 2017

The right of George Woods to be identified as
the Author of this work has been asserted in
accordance with the Copyrights, Designs and
Patents Act 1988.

ISBN 978 1 4456 6822 2 (print)
ISBN 978 1 4456 6823 9 (ebook)

British Library Cataloguing in Publication Data.
A catalogue record for this book is available from
the British Library.

Origination by Amberley Publishing.
Printed in the UK.

# Introduction

The South Western section of the Southern Region of British Railways was one of the last bastions of steam in Britain. This seems rather unlikely as before the Second World War the Southern Railway had a program of third-rail electrification that covered a large part of its system, including the line from Waterloo to Guildford, which was electrified as long ago as 1925.

After the war the electrification program resumed and during the 1950s the South Eastern main lines from Charing Cross to the Kent coast were completed. It was announced that the next electrification project would be the main line from Waterloo to Bournemouth, which was finished in 1967, with the section on to Weymouth completed in 1988.

Among the reasons the South Western lines were last to be electrified was because of the age of the steam locos in use. Most of the locos on the South Eastern lines were coming to the end of their days, but on the South Western lines most trains were worked by the modern Pacifics, designed by Oliver Bulleid for the Southern Railway, which were built between 1941 and 1951.

There were two different types of Pacific, both powered by three cylinders. The first was the larger Merchant Navy (MN) Class, which were named after shipping lines that operated from Southampton and the Channel ports. The second was the smaller West Country/Battle of Britain (WC/BB) Class, which were named after towns served by the Southern in the West Country, and airfields, squadrons, aircraft and personalities that took part in the Battle of Britain, which was largely fought over areas served by the Southern Railway.

Bulleid's two Pacific designs had many original features, such as the chain-driven inside valve gear enclosed in an oil bath, which often leaked and on occasion completely collapsed, depositing large amounts of oil on to the track. A welded steel firebox was used and contained a thermic syphon and the locos were covered in a casing that was meant to make cleaning easier, but made some maintenance tasks more difficult than they should have been, which, combined with the oil leaks from the enclosed valve gear, caused some serious fires.

In the mid-1950s, because of these problems, it was decided to rebuild the Pacifics. The first rebuilt Merchant Navy emerged from Eastleigh Works in 1955 and all thirty were completed by 1958.

Of the 110 WC/BB locos, sixty were rebuilt between 1957 and 1961. It was decided not to rebuild all the light Pacifics as it was thought that diesels and electric trains would be taking over their duties in the not too distant future.

The most important train to run from Waterloo was the Atlantic Coast Express (ACE), which ran all year round and served as many as eight resorts in Devon and Cornwall. In the peak summer months this train could run in many parts from Waterloo, such was the demand. However, when the Western Region took over all the former Southern lines west of Salisbury in 1963, the writing was on the wall, and the ACE made its final journey on 5 September 1964. With the Beeching cuts, many of the places served by the ACE lost their rail services altogether.

The first stage of the modernisation plan was the introduction of diesel locos to the West Country services from Waterloo. Warship Class diesel-hydraulics from the Western Region were used to work a stopping service as far as Exeter, concentrating the express services on the West of England main line from Paddington. Much of the former Southern route west of Salisbury was changed to a single line with passing places, which became a major source of delay when services were disrupted.

Despite the introduction of diesels, some Salisbury line services remained steam-hauled, and Salisbury-based Pacifics were usually kept well-maintained in comparison to those from Nine Elms in particular because of the difficulties in recruiting staff in the London area.

The line from Waterloo to Bournemouth and Weymouth remained largely steam-worked until early 1967 when Brush Type 4s from the Western Region and Southern-based Class 33 diesel and Class 73 electro diesels took over some of the services.

The premier train on the route in late steam days was the Bournemouth Belle Pullman, which stopped only at Southampton and could load up to about 500 tons, usually being worked by a Merchant Navy Class loco. This train left Waterloo at 12.30 and returned from Bournemouth at 16.37 with a journey time of about two hours.

Another very important steam-hauled service from Waterloo was the boat trains to and from the Ocean Liner Terminal in Southampton Docks, some of which included Pullman cars. These conveyed passengers for transatlantic liners, such as Cunard Line's *Queen Elizabeth* and *Queen Mary*, and the United States Line's *America* and *United States*. Hollywood film stars and other famous personalities of the time were regular travellers by these services, and old newsreel footage from the mid-fifties shows Bill Hayley, among others, arriving at Waterloo behind a Lord Nelson, and emerging from a Pullman car to be greeted by crowds of fans. The locos used on these services until about 1962 were Lord Nelson and King Arthur Class 4-6-0s, after which Bulleid Pacifics and Standard Class 5s took

over. Many other shipping lines were served by specials, including Peninsular & Oriental Lines, Union Castle and Shaw Savill. This traffic all but disappeared with the coming of the Jet Age, with which the ships were not able to compete, but is gradually increasing again as more cruise ships are sailing from Southampton.

Boat trains also ran from Waterloo to Weymouth Quay to connect with sailings to the Channel Islands, and were mostly steam-hauled.

The banana trains were another steam-hauled traffic from Southampton Docks, which worked into the large goods depot at Nine Elms and consisted of special wagons that could be steam-heated to assist with the ripening of the fruit.

A sad loss to the enthusiast was the end of steam on the Isle of Wight. There had once been a comprehensive rail system on the island but over the years this had been whittled down to just one line between Ryde Pier Head and Shanklin.

The attraction to the enthusiast, and probably a lot of islanders, was the age of the equipment. As the island is only linked to the mainland by ferry, bringing any new rolling stock across is a major operation. The ex-LSWR Class O2 locos that worked the trains dated from 1889, and were first introduced to the island in 1923 to replace older locos, until eventually twenty-three were in service. The coaching stock was just as old; some originated from the London & South Western and others from the London Brighton & South Coast Railway and dated from the late nineteenth century.

It was decided to electrify the line from Ryde to Shanklin using the third rail system, and the last steam trains ran on 31 December 1966, after which the line was closed for three months to allow completion of the electrification work. The tradition of using hand me down rolling stock continued as the 'new' trains came from the London Transport Piccadilly and Northern lines, and were about forty years old.

The major railway societies ran many enthusiast special trains over the last eighteen months, featuring all the Southern-based loco types, plus many others, including some that were brought from as far away as Scotland – sometimes with disappointing results. Most of these specials were very popular, and on several occasions so many wanted to travel that a duplicate tour on another date had to be run.

The Longmoor Military Railway was tucked away on the South Downs in Hampshire and was a popular destination for special trains as it had some fifty miles of track that was used for training purposes by the Army. There were many open days and passenger trains were run on the system usually in conjunction with a special from London. The Ministry of Defence decided in the late sixties that they no longer needed the railway and several societies hoped to open a large museum on the site, but this proposal was defeated by local residents and the railway closed on 31 October 1969.

The LSWR had a large workshop and running sheds at Nine Elms, about three miles from Waterloo, which opened in 1865 to replace the original works built in 1839. However, by the late 1880s the site was becoming too cramped and a large site for a new Works and running shed was found at Eastleigh, near Southampton.

This opened in 1891, leaving just the running sheds at Nine Elms, which survived until the end of steam in 1967.

Eastleigh Works was responsible for the major maintenance and overhauls of all the locos and rolling stock that ran on the LSWR, and in later years the Southern Railway and British Railways' South Western section. Major work on steam locos finished on 6 October 1966, when No. 34089 left the works, but the occasional light repair was carried out after that date.

The works are still open today, carrying out major rebuilds and maintenance for the privatised rail companies.

The last steam-hauled passenger train ran on Sunday 9 July 1967 with the 14.07 from Weymouth to Waterloo hauled By MN No. 35030 *Elder Dempster Lines*, but the very last one was a van train that was hauled from Bournemouth to Weymouth by Std 3 No. 77014, which arrived in Weymouth at about 22.00, and that was it.

The redundant steam locos were gathered at Weymouth and Salisbury and were gradually towed away to scrapyards in South Wales, but a few lingered at Nine Elms and it would be August before they had all gone. The last locos had left Salisbury by the end of March 1968 and within a few more weeks Southern Steam was gone, but not forgotten.

In May 1967 The Kinks released a record entitled 'Waterloo Sunset', which became a great hit. Was it a coincidence that the record came out just at the end of Southern Steam? There is only a passing reference to Waterloo station, but I have often wondered if Ray Davies was a secret steam enthusiast, and had the end of Southern Steam in mind when he wrote the song.

# Abbreviations

| | |
|---|---|
| BB | Battle of Britain |
| BR | British Railways |
| LCGB | Locomotive Club of Great Britain |
| LSWR | London South Western Railway |
| MN | Merchant Navy |
| MPD | Motive Power Depot |
| RCTS | Railway Correspondence and Travel Society |
| SCTS | Southern Counties Touring Society |
| Std | Standard |
| WC | West Country |

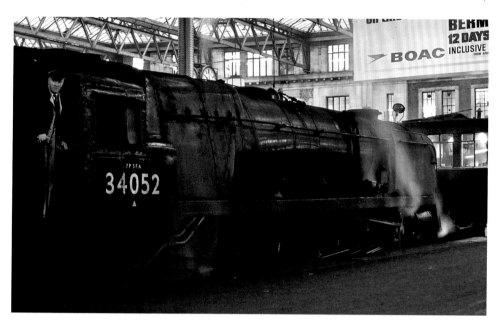

BB No. 34052 *Lord Dowding* has just arrived at Waterloo station with a train from Salisbury on 4 July 1967.

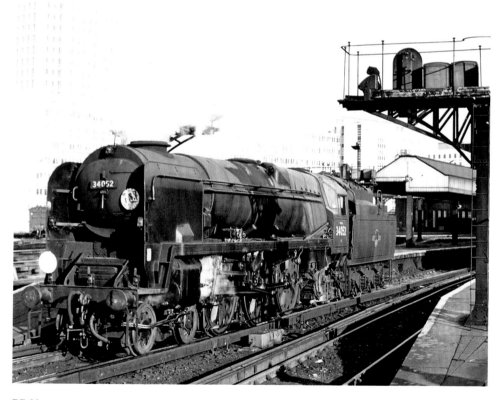

BB No. 34052 *Lord Dowding* is backing onto its train at Waterloo station on 16 October 1966. No. 34052 appears in at least six pictures in this book. It seemed to follow me around, but it was always a pleasure to see it because, as a Salisbury-based loco, it was usually kept in good condition.

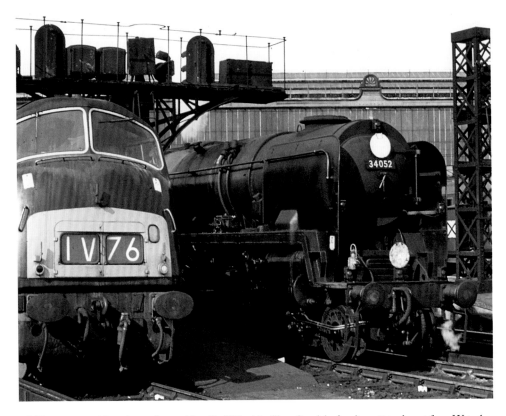

BB No. 34052 *Lord Dowding* and an unidentified Warship Class diesel-hydraulic wait to depart from Waterloo station with trains to Salisbury and Exeter on 4 July 1967.

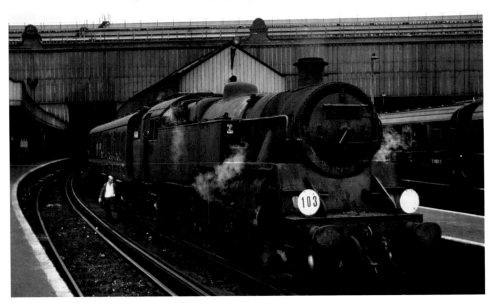

Std 4 No. 80089 waits to leave Waterloo station on 29 September 1966 with empty carriages for the sidings at Clapham Junction.

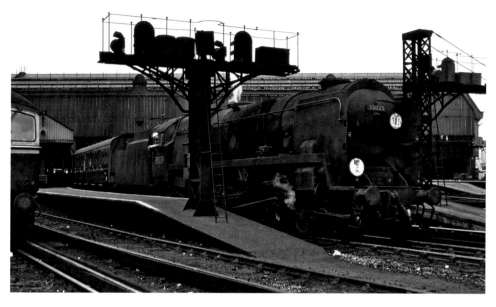

MN No. 35029 *Ellerman Lines* is ready to leave Waterloo station on 29 September 1966 with a Bournemouth line train.

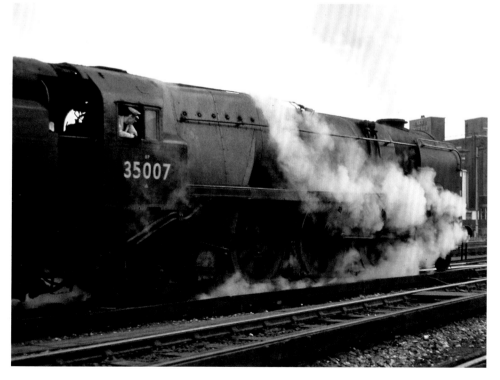

MN No. 35007 *Aberdeen Commonwealth* spins its driving wheels on slippery rails as it gets away from Waterloo station on 29 September 1966 with a westbound express.

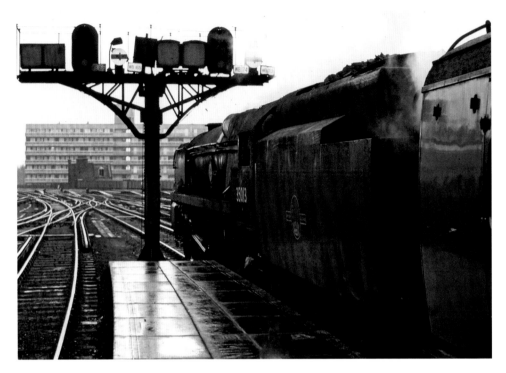

MN No. 35013 *Blue Funnel* waits to depart from Waterloo station with the 08.35 to Weymouth on 12 December 1966. Dominating the background is the block of flats from which the next five photos in this book were taken.

WC No. 34102 *Lapford* and No. D868 *Zephyr* wait outside Waterloo station on 4 July 1967 to back down onto their trains. No. 34102 is the 18.54 to Salisbury, and No. D868 is a train to Exeter.

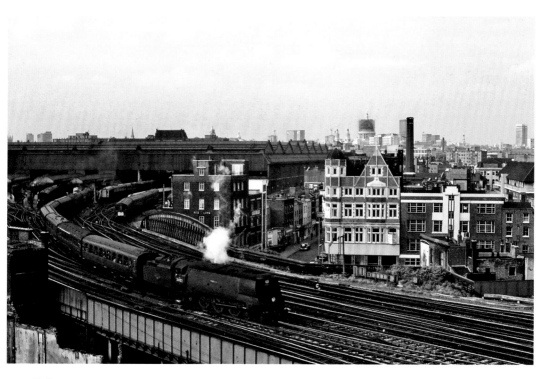

WC No. 34102 *Lapford* leaves Waterloo station on 4 July 1967 for the last time with the 18.54 to Salisbury. It would work its very last train back to Waterloo the next day. This was, of course, also the last un-rebuilt Pacific to work out of Waterloo.

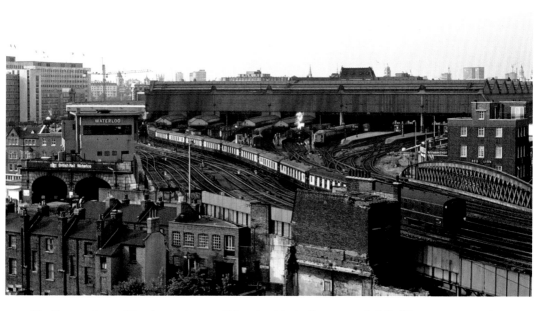

No. D1925 arrives at Waterloo station on 4 July 1967 with the Bournemouth Belle. These views were taken from the flats overlooking the station, and some of the occupants were not too pleased to see photographers outside their front doors, so we had to keep changing floors.

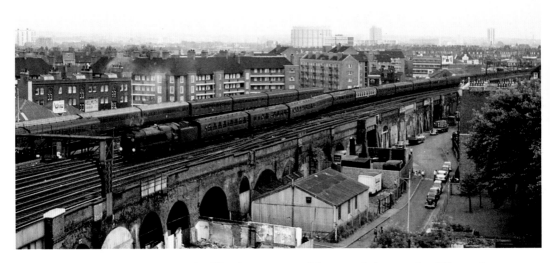

BB No. 34087 *145 Squadron* approaches Waterloo station on 4 July 1967 with the 16.00 from Weymouth.

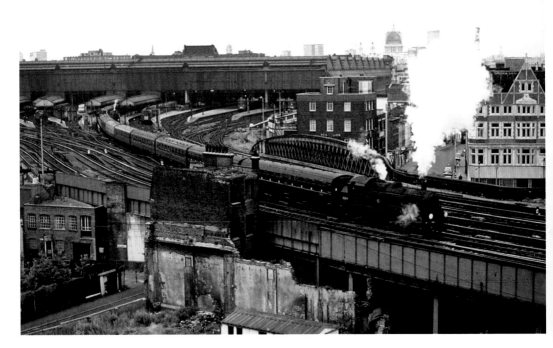

No. 82019 leaves Waterloo station on 4 July 1967 with the empty stock of the Weymouth train seen in the previous picture. The first coach is one of the few Bulleid-designed vehicles that were repainted from Southern Green into BR Maroon.

BB No. 34052 *Lord Dowding* passes Vauxhall station on 29 September 1966 with a Salisbury line train.

WC No. 34006 *Bude* passes Vauxhall station with a rush hour train on 29 September 1966.

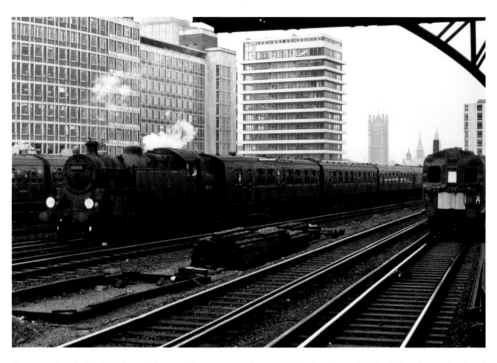

No. 80145 heads for Clapham sidings with empty stock as a 4-Sub electric makes for Waterloo with a local service. Taken at Vauxhall station, 29 September 1966.

Nine Elms MPD is seen from a passing train on the main line out of Waterloo on 14 August 1966. The loco is A2 No. 60532 *Blue Peter*, which had come from Scotland to work a railtour that day.

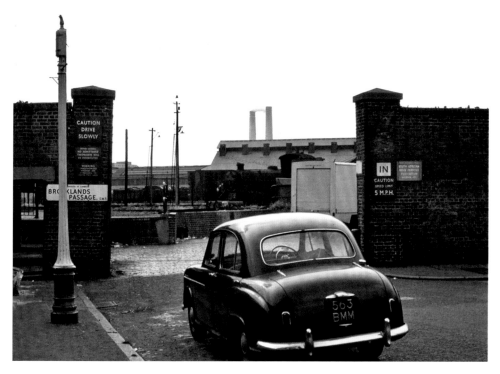

The official entrance to Nine Elms MPD, as seen on 2 October 1966, was from Brooklands Place, but as the foreman's office was just inside to the left, many an unofficial visit came to an end very quickly.

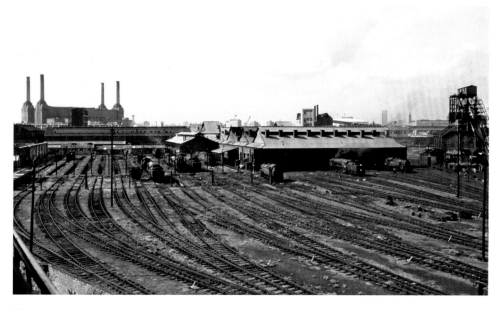

The panoramic view from the flats overlooking Nine Elms MPD, taken in May 1967. In the background, the huge bulk of Battersea Power Station dominates the scene. The Old Shed on the left-hand side of the picture was severely damaged by bombing during the Second World War and was never rebuilt, finishing up as open storage for locos. Next to the site of the Old Shed is the New Shed, which was built in 1910, and to the right of the picture stands the large coaling tower.

The next thirteen pictures were taken on 2 October 1966 – a quiet Sunday afternoon – and show most of the types that were operating from Nine Elms at the time. Along with many sheds at the end of steam, the working conditions here were terrible, the buildings were in very bad condition, and the facilities provided for the staff basic in the extreme, but somehow the locos were kept going and the cancellation of trains because of a lack of locos was rare.

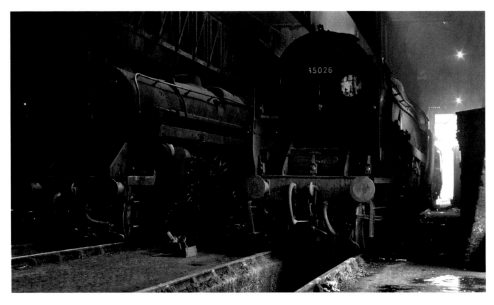

Std 5 No. 73113 *Lyonesse* still has its nameplate, as does MN No. 35026 *Lamport & Holt Line*, both seen inside the running shed. Also seen are WC No. 34040 *Crewekerne* and un-rebuilt WC No. 34102 *Lapford*.

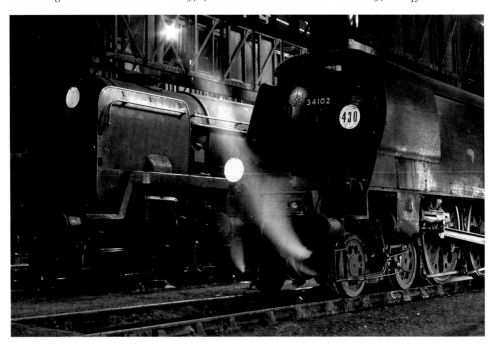

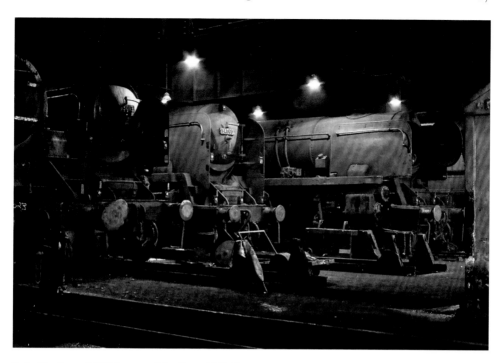

Std 3 No. 82023, MN No. 35013 *Blue Funnel*, BB No. 34060 *25 Squadron*, WC No. 34017 *Ilfracombe* and WC No. 34002 *Salisbury* are lined up at the rear of the shed, undergoing repairs.

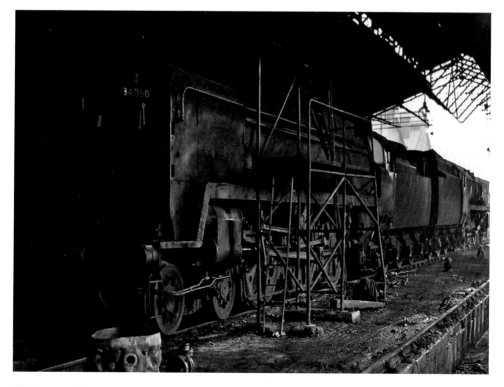

BB No. 34090 *Sir Eustace Missenden* and a Merchant Navy are seen alongside the running shed under repair.

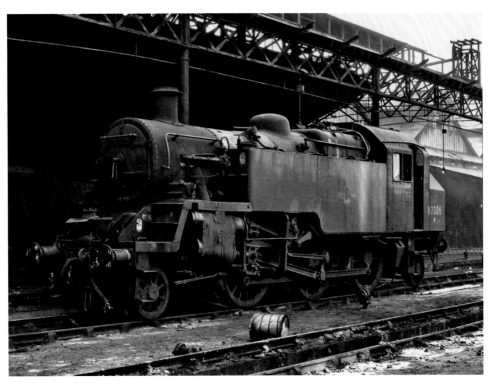

Std 3 No. 82006, in a very faded green livery, has been withdrawn from service and waits to make its final journey to the scrap yard at Buttiglegs in Newport.

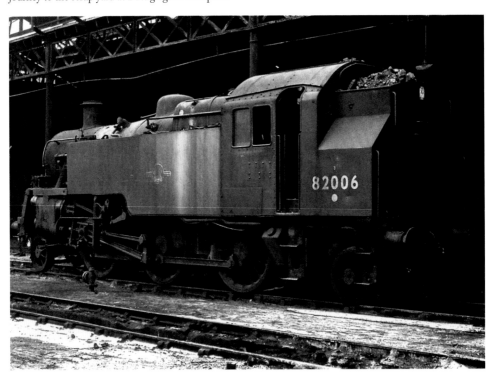

Un-rebuilt BB No. 34057 *Biggin Hill* and Std 5 No. 73083 *Pendragon* are among other locos stood outside the Old Shed awaiting their next duties.

WC No. 34032 *Camelford* and WC No. 34040 *Crewekerne* are stood outside the running shed. No. 34040 is about to make its way to Waterloo to head an afternoon Bournemouth line train.

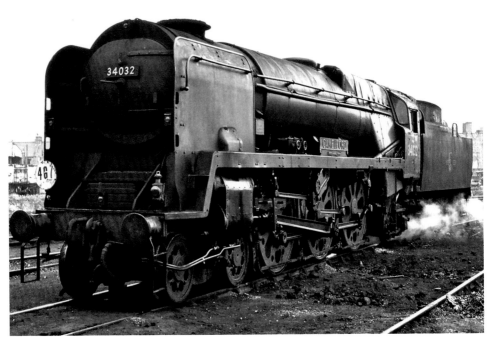

WC No. 34032 *Camelford* still had both nameplates at this time and sits alongside the huge coaling plant that towers over the shed.

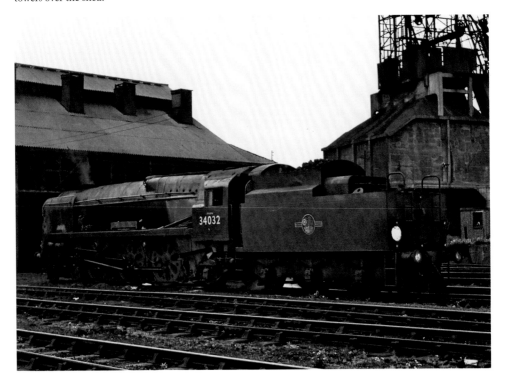

Std 4 No. 80143 is acting as the shed pilot but as it is Sunday, there is not much for it to do.

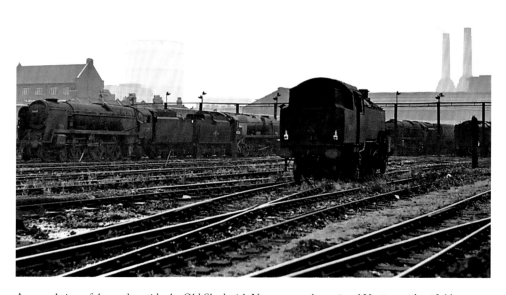

A general view of the yard outside the Old Shed with Nos 35029 and 34026 and No. 80143 identifiable.

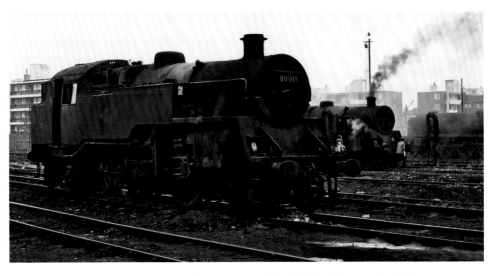

Std 4s No. 80015 and No. 80143 stand outside the remains of the Old Shed. No. 80143 looks like it is getting up steam, ready to work empty stock into and out of Waterloo station.

The next eight pictures were taken at Nine Elms during early May 1967, when steam workings were getting fewer. A friend and I decided to spend a couple of hours during the afternoon on the balcony of the flats overlooking the shed, and it certainly gave us a fine view over the surrounding area, which was also about to change for ever over the next few years. After the shed closed with the end of steam on 9 July 1967 it was demolished, and the whole area was cleared to permit the building of a new fruit and vegetable market to replace Covent Garden Market. This eventually opened in November 1974.

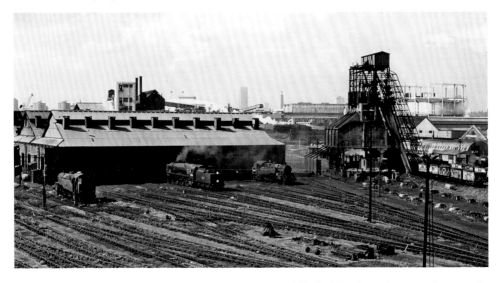

A view looking across to the New Shed and the coaling plant. A Bulleid Pacific can be seen in between the New Shed and the coaling plant, backing down to Waterloo station. Beyond that, on the far side of the South Western Main Line, is Nine Elms Gas Works, which closed in 1970; the site was then used for a new Royal Mail sorting office.

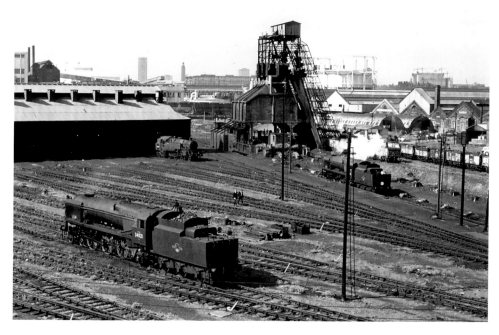

WC No. 34021 *Dartmoor* is waiting to be moved by the shed pilot as WC No. 34108 *Wincanton* heads towards the ash pit.

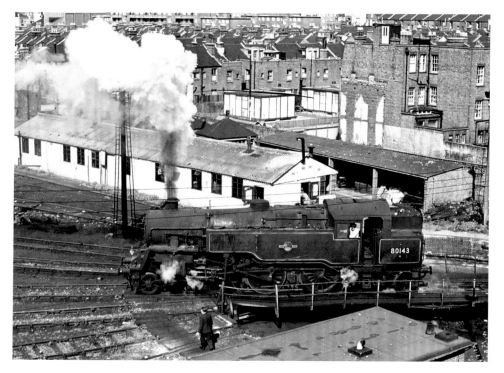

Std 4 No. 80143 moves off the turntable. The constant movement of locos on and off the turntable and the dust from the busy ash pits and the coaling tower must have been very unpleasant for the neighbouring properties.

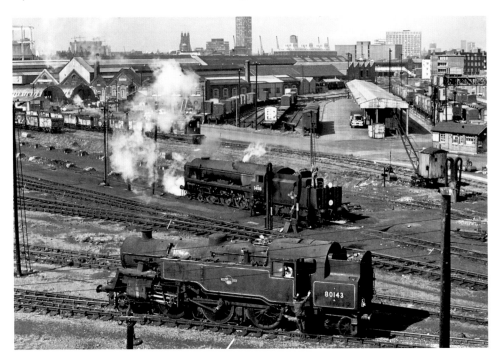

Std 4 No. 80143 moves up the yard as No. 34108 finishes taking water. To the right of No. 34108 is the ancient steam grab that kept the ash pits clear. In the background, container wagons can be seen in the Brooklands Yard, which was part of the large Nine Elms Goods Depot that extended to both sides of the main line.

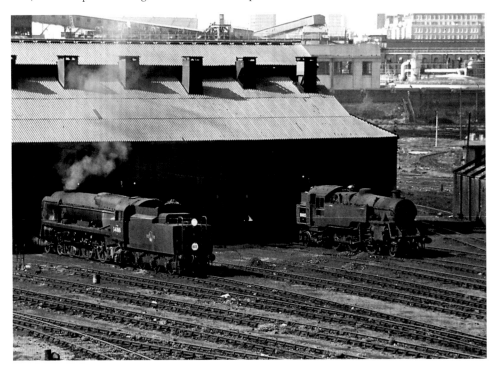

WC No. 34108 *Wincanton* and Std 4 No. 80085 stand outside the shed ready for their next duties.

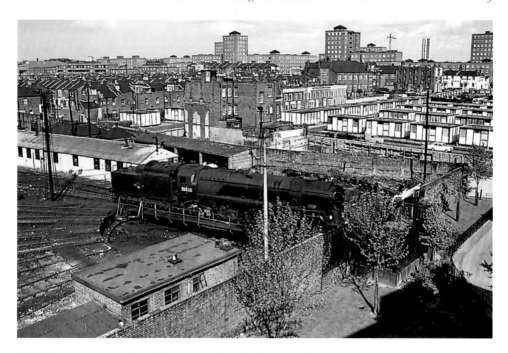

MN No. 35028 *Clan Line* has taken water and had its fire cleaned, and is on the turntable ready to move to the shed. In the background is a selection of typical South London housing, some still showing scars from the Blitz and a lot of Prefabs still surviving in use. Most of this will be swept away when the loco shed site is redeveloped for the new fruit and vegetable market.

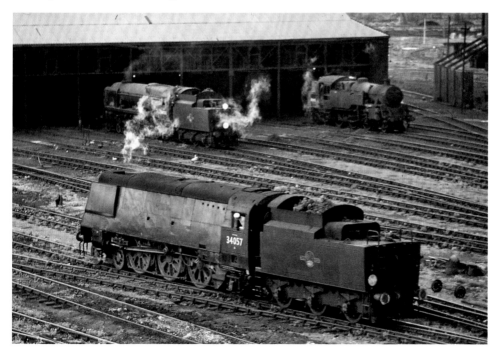

BB No. 34057 *Biggin Hill* moves towards the outside road of the old shed. The loco was withdrawn about this time and it is possible that this was its last movement in steam.

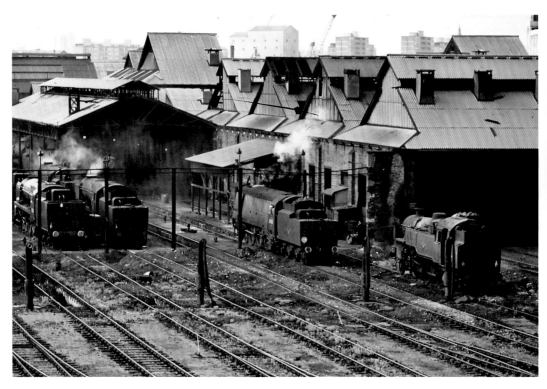

A final view from the flats of the remaining part of the old shed with a few locos outside the dilapidated new shed.

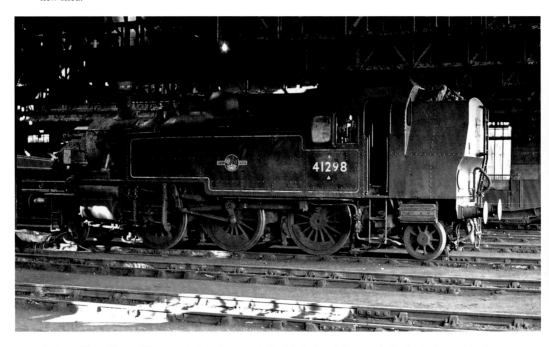

A view of Ivatt Class 2 No. 41298 inside the new shed with the breakdown train in the background, taken on 4 July 1967. No. 41298 has been preserved and is now at the Isle of Wight Railway.

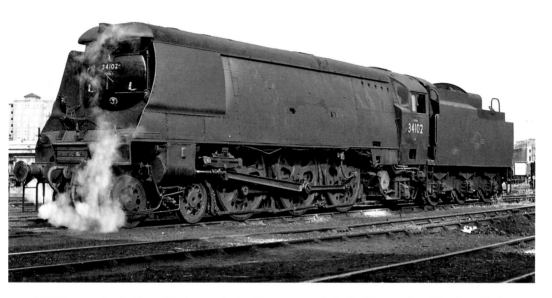

WC No. 34102 *Lapford* is outside the new shed and is ready to make its final journey from Waterloo with the 18.54 to Salisbury. It would make the return journey from Salisbury the next day, then be withdrawn.

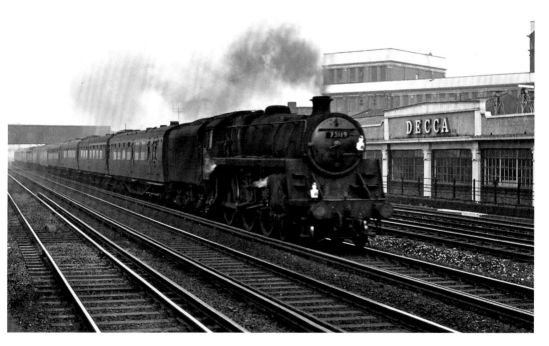

Std 5 No. 73119 *Elaine* passes Queens Road Battersea station on 2 October 1966 with a Bournemouth line express. In the background is the Decca Radio and Television works in Ingate Place.

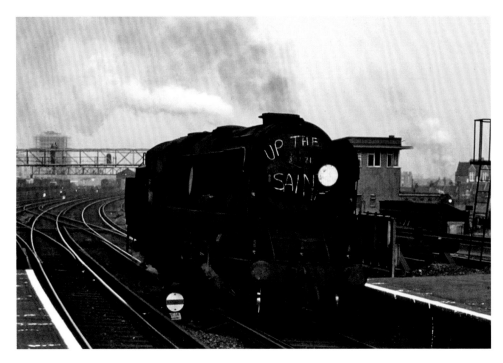

BB No. 34071 *601 Squadron* runs light engine through Clapham Junction station in September 1966, complete with Southampton Football Club slogan on the smokebox. To the right of the signal box a Std 4 is arriving with a train from Kensington Olympia.

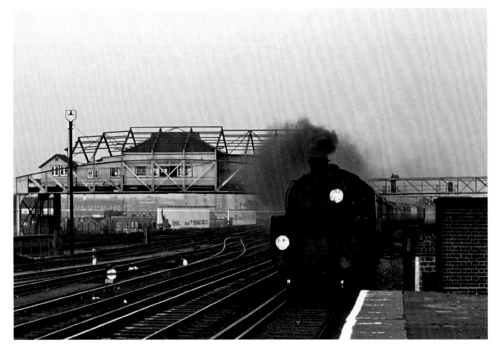

An unidentified Std 5 passes Clapham Junction station in September 1966, passing the Clapham Junction A signal box, which partially subsided in May 1965, closing Waterloo station for several days.

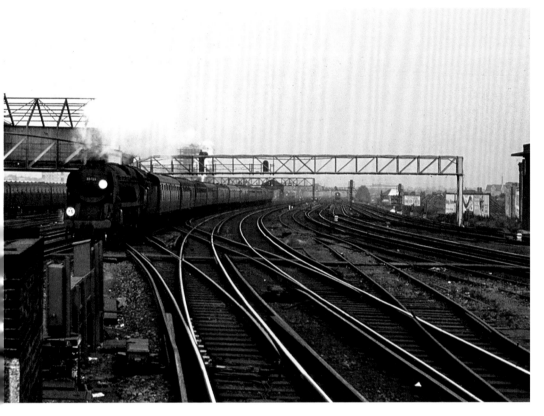

MN No. 35023 *Holland Afrika Line* passes Clapham Junction with a Weymouth express. To the right is Clapham Junction B signal box. Taken September 1966.

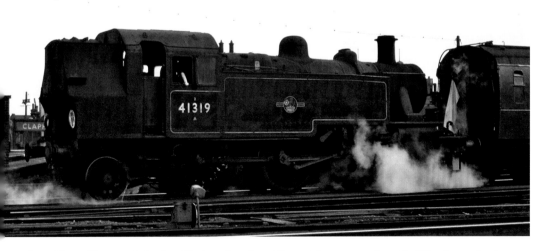

Ivatt Class 2 No. 41319 is leaving Clapham Junction sidings with empty carriages for Waterloo station in September 1966.

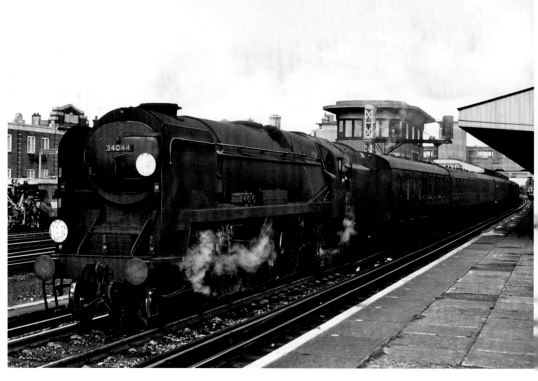

WC No. 34044 *Woolacombe* leaves Woking station on 1 October 1966 with a Bournemouth line train.

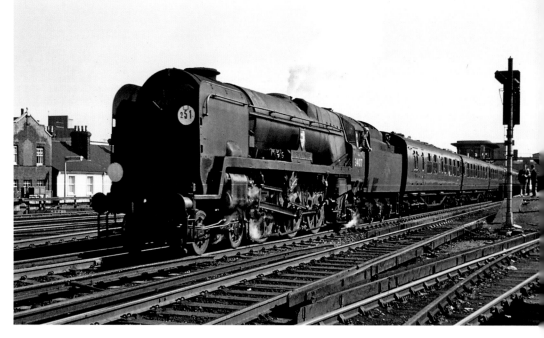

WC No. 34017 *Ilfracombe* leaves Woking station on 30 April 1966 with a westbound express.

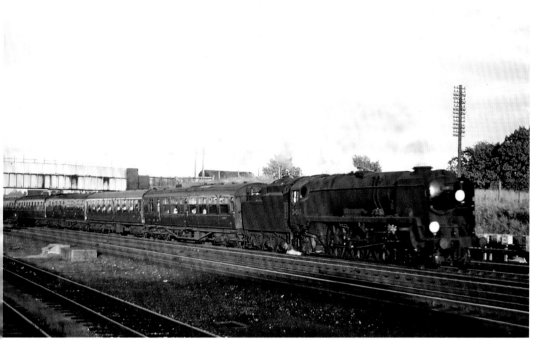

WC No. 34047 *Callington* is about a mile south of Woking, heading west with an express on 1 October 1966.

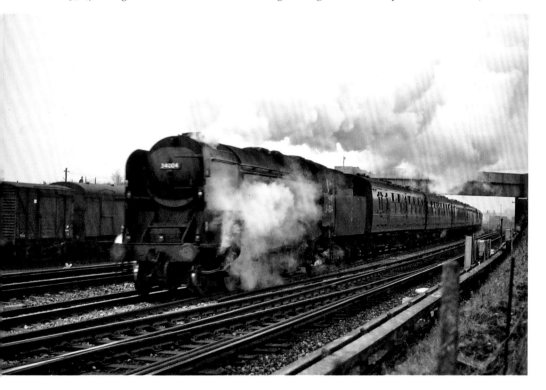

WC No. 34004 *Yeovil* accelerates away from Woking with a westbound train. Taken on 4 December 1966.

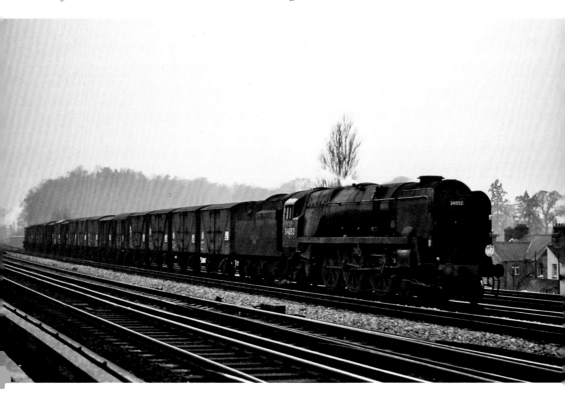

BB No. 34052 *Lord Dowding* is about to pass through Woking as it makes for Nine Elms goods depot with a banana train from Southampton Docks. On the rear is one of the Southern Railway Queen Mary bogie brake vans. Taken on 4 December 1966.

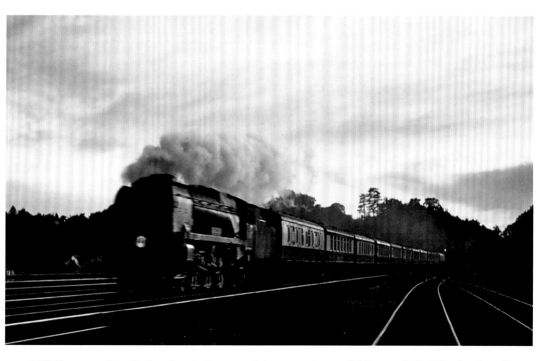

WC No. 34032 *Camelford* catches the last rays of the sun as it nears Woking with the Waterloo-bound Bournemouth Belle Pullman train on 1 October 1966.

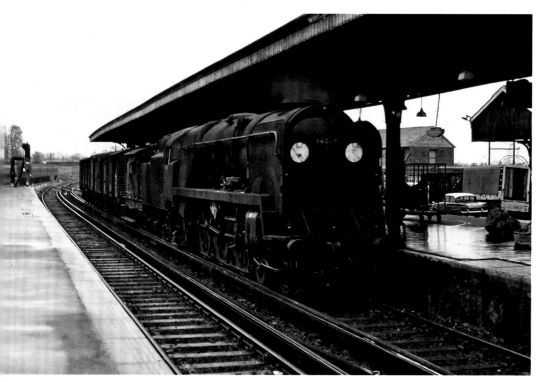

WC No. 34034 *Honiton* arrives at Guildford station with a parcels train on 1 February 1967.

Std 4 No. 76053 and BB No. 34071 *601 Squadron* are seen at Guildford MPD on 1 February 1967. No. 76053 has been recently withdrawn and will finish up at Cashmore's yard in Newport for scrap.

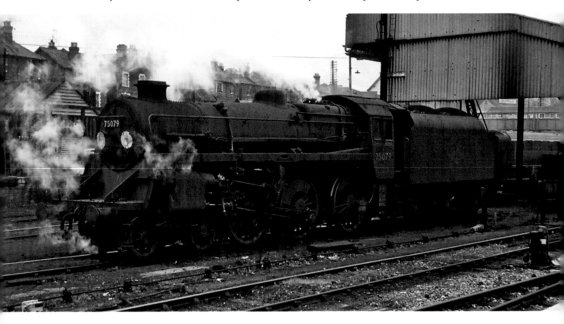

Std 4 No. 75079 is seen by the coaling shed at Guildford MPD on 3 April 1966.

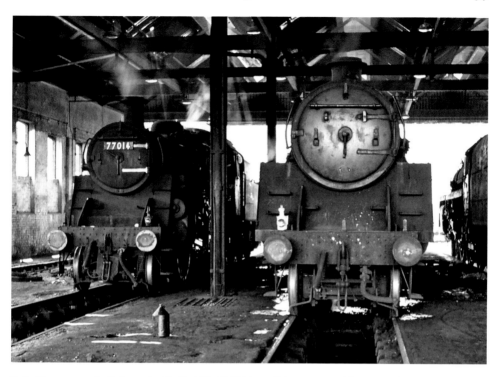

Std 3 No. 77014 and a Std 5 are inside Guildford MPD on 1 February 1967. After steam finished the shed was closed and the site was used as the station car park.

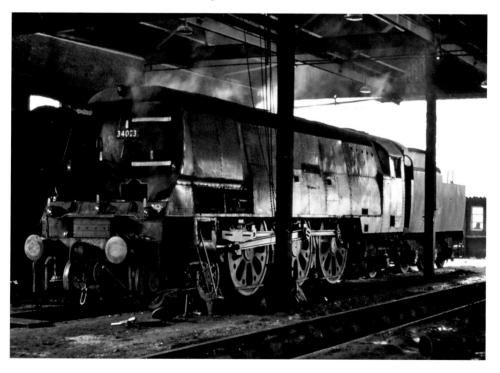

WC No. 34023 *Blackmore Vale* is undergoing work on its cylinders inside Guildford MPD on 1 February 1967.

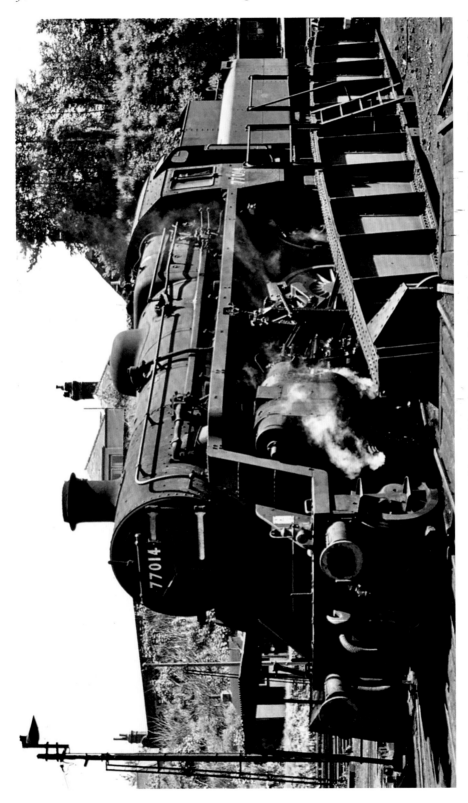

Std 3 No. 77014 sits on the Guildford MPD turntable on 18 June 1967. Twenty of these locos were built and all were allocated to sheds in the north of England and Scotland. No. 77014 was sent to Guildford in April 1966 and was the last steam loco to work a train on 9 July 1967 – the final day of steam.

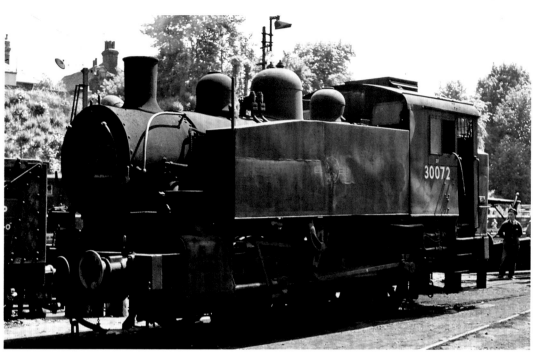

USA Class No. 30072 is at Guildford MPD on 18 June 1967. Nearly 400 of these locos were built in America for use in Europe during the Second World War. When the war ended, fourteen of these locos were purchased by the Southern Railway for use as shunters in Southampton docks. No. 30072 was saved from scrap and was restored to working order on the Keighley & Worth Valley Railway.

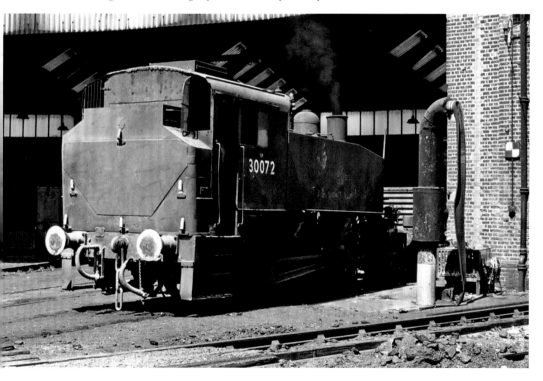

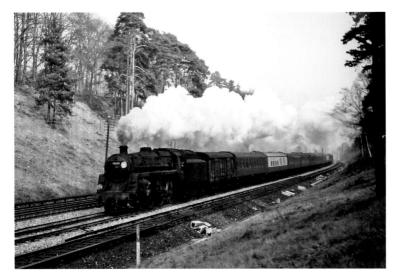

Std 5 No. 73020 heads
the 13.30 Waterloo to
Weymouth train through
Woking Cutting on
14 February 1967.

WC No. 34104 *Bere
Alston* races through
Brookwood station with a
Waterloo-bound express
on 1 February 1967.

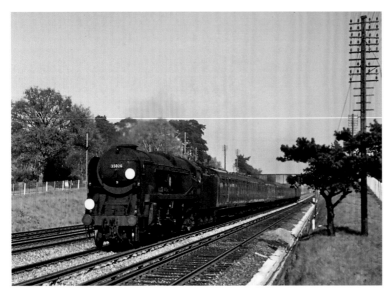

MN No. 35026 *Lamport
and Holt Line* heads
a westbound train
near Farnborough on
30 April 1966.

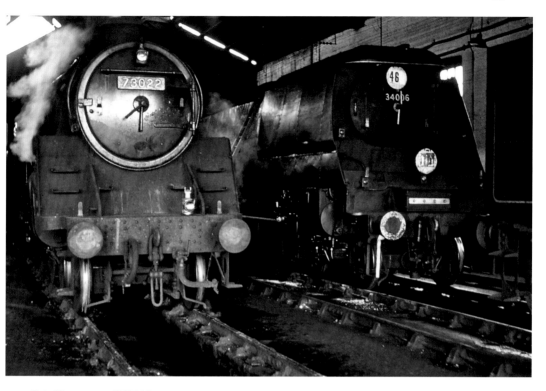

Std 5 No. 73022 and WC No. 34006 *Bude* are seen in Salisbury MPD on 3 April 1966.

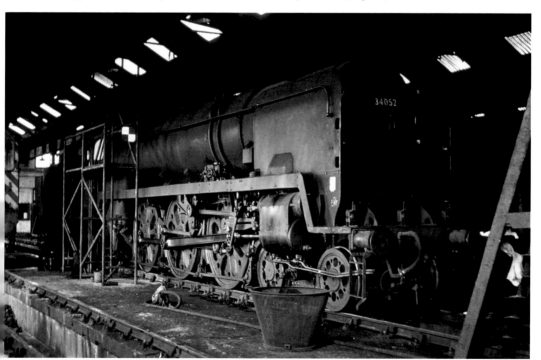

BB 34052 *Lord Dowding* is inside its home depot at Salisbury MPD on 3 April 1966.

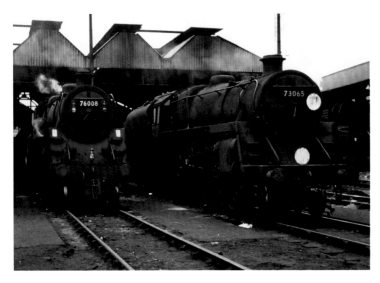

Std 4 No. 76008 and Std 5 No. 73065 are outside Salisbury MPD on 3 April 1968.

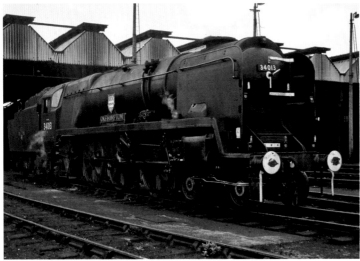

WC No. 34013 *Oakhampton* stands outside Salisbury MPD on 14 August 1966. No. 34013 was one of my favourite locos as it was kept in immaculate condition and kept its nameplates almost until the end.

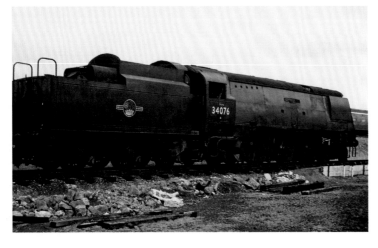

Un-rebuilt BB No. 34076 *41 Squadron* at Salisbury MPD on 14 August 1966 looks to be in good condition but is waiting to be towed away for scrap at Cashmore's of Newport.

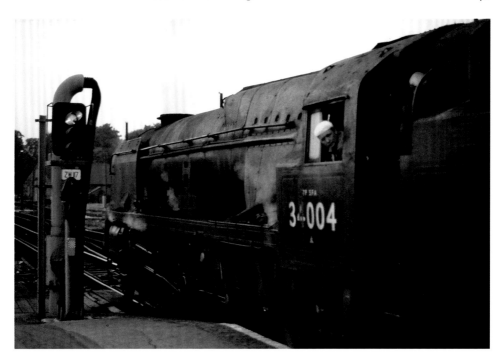

WC No. 34004 *Yeovil* is at Winchester station on 6 July 1967 with the 17.30 from Weymouth to Waterloo, which was the last journey that I made behind Southern steam.

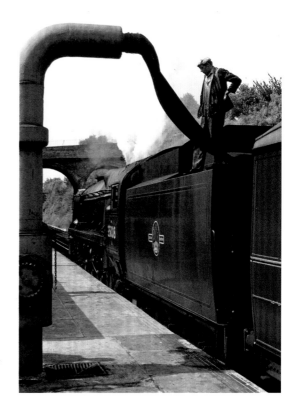

MN No. 35008 *Orient Line* takes water at Winchester station on 6 July 1967 with the 08.35 Waterloo to Weymouth train. The first vehicle in this train was an empty Gresley buffet car.

The next ten pictures were taken at Eastleigh MPD during a visit made with the Locomotive Club of Great Britain on Saturday 19 March 1966.

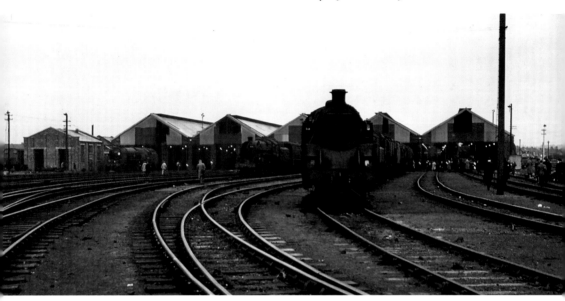

A general view of the shed at Eastleigh MPD, showing the five three-road sheds, which was one of the largest MPDs on the Southern Region.

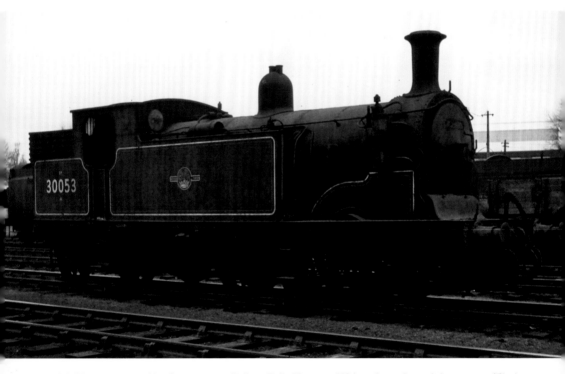

M7 No. 30053 was sold to Steamtown at Bellows Falls, Vermont, USA, and was shipped there in 1967. The loco returned to the UK in 1987 and can be seen at the Swanage Railway.

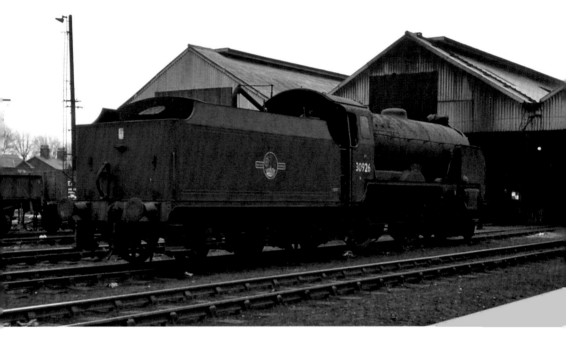

Schools Class No. 30926 *Repton* was also sold to Steamtown and was loaned to the Cape Breton Steam Railway in Canada for a while. No. 30926 returned to the UK in 1989 and is now in service on the North Yorkshire Moors Railway.

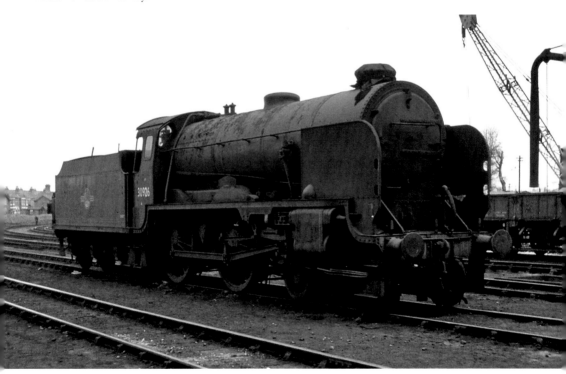

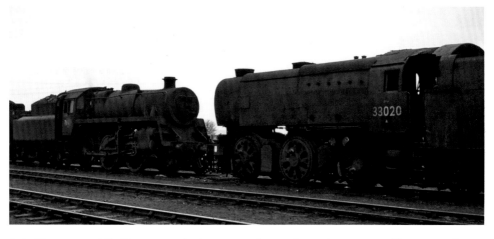

Std 4 No. 76019 and Q1 No. 33020 are both waiting to be towed away for scrapping. No. 76019 will go to Cohens of Morriston and No. 33020 to Buttiglegs of Newport.

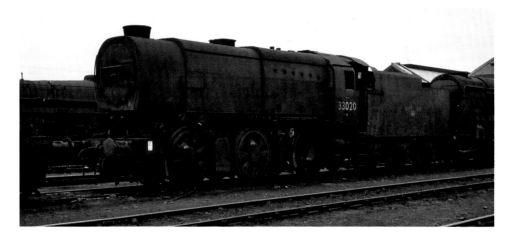

Q1 No. 33020 was built in 1942 and, because of the shortage of materials, anything that was not essential to the operation of the loco was left off, resulting in a rather strange-looking loco that was, however, very effective in service.

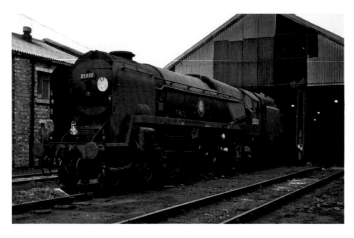

MN 35030 *Elder Dempster Lines* stands outside the shed after undergoing repairs.

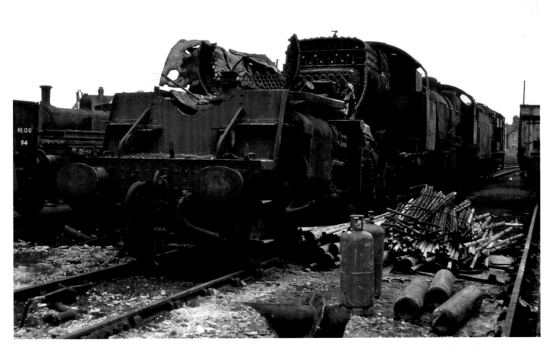

Std 4 No. 80132 is being broken up at Eastleigh shed by Cohens Scrap Ltd. Next in line, N Class No. 31866 awaits its turn for the torch.

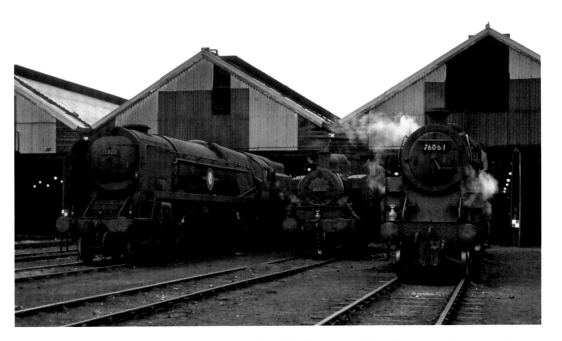

MN No. 35023 *Holland Afrika Line* is under repair, but USA No. 30071 and Std 4 No. 76061 are in steam, ready for their next duties.

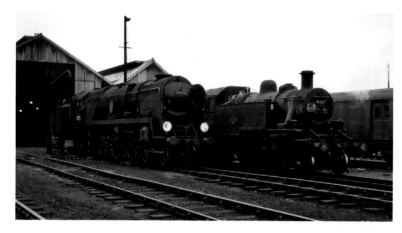

BB No. 34071 *601 Squadron* and Ivatt 2 No. 41287 wait to work their next trains.

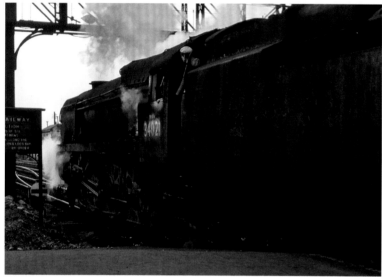

WC No. 34021 *Dartmoor* leaves Eastleigh station on 19 March 1966 with the 08.35 Waterloo to Weymouth train.

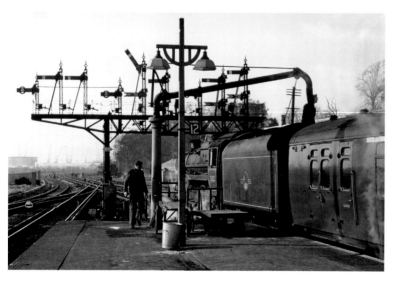

Std 5 No. 73156 takes water at Southampton station on 16 February 1967. In the background the cranes in Southampton docks dominate the skyline and the famous signal gantry lasted until resignalling took place in 1982.

The next seven pictures were taken at Brockenhurst station, which is the junction for the branch line to Lymington Pier and the ferry to Yarmouth on the Isle of Wight.

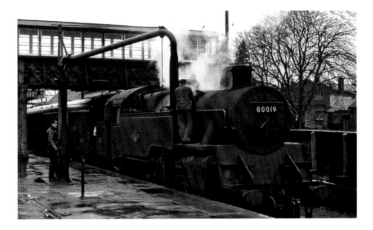

Std 4 No. 80019 has just arrived on 16 February 1967 with the branch line train from Lymington Pier, and takes water before reversing across the main line.

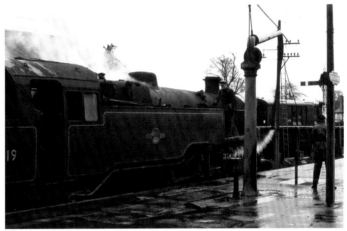

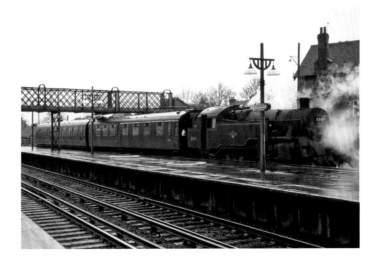

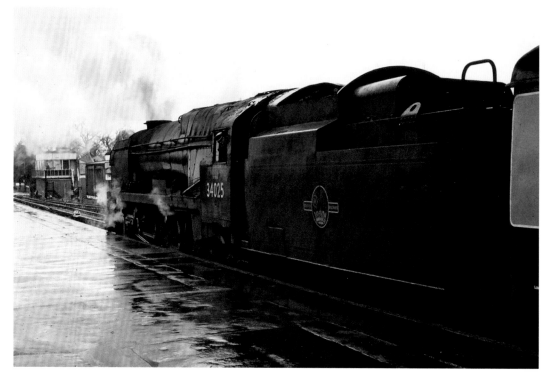

WC No. 34025 *Whimple* waits to leave on 16 February 1967 with a train for London Waterloo.

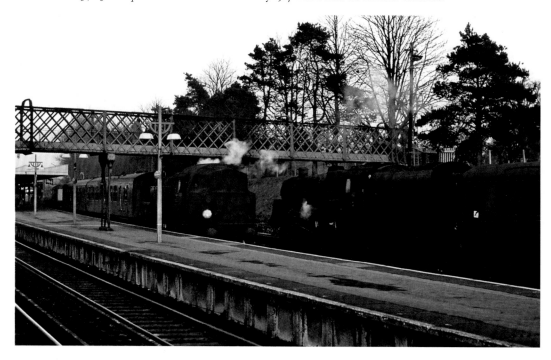

Std 4 No. 80011 propels its train into the Lymington platform, as Std 5 73092 shunts the yard alongside Brockenhurst station on 2 January 1967.

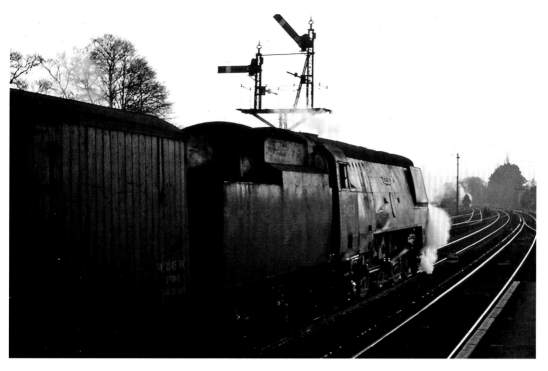

BB No. 34057 *Biggin Hill* prepares to depart on 2 January 1967 with the 13.30 from Waterloo to Weymouth.

WC No. 34021 *Dartmoor* is about to depart into the sunset on 8 February 1967 with the 10.08 York to Bournemouth train.

Std 4 No. 80019 waits to leave Lymington Pier station for Brockenhurst on 16 February 1967.

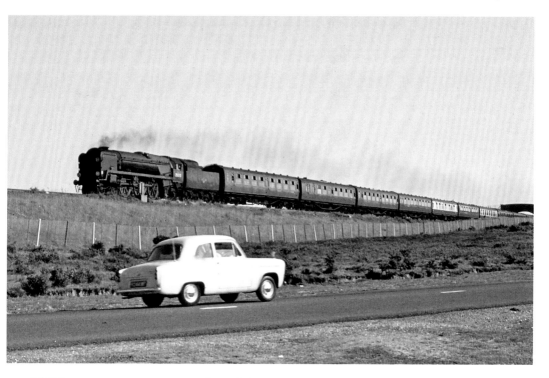

MN No. 35030 *Elder Dempster Lines* descends Sway Bank and approaches Lymington Junction with an express for Waterloo on 14 June 1967. The local drivers seem to like Ford cars, with a 100E and an Anglia getting in the pictures.

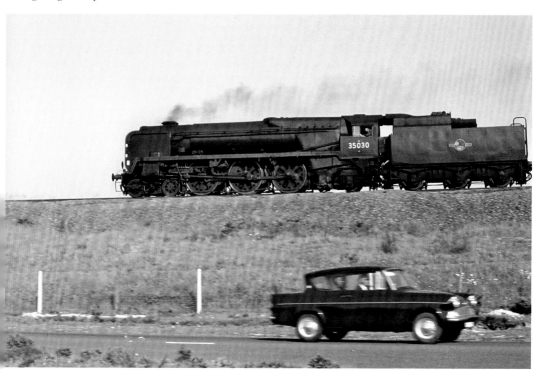

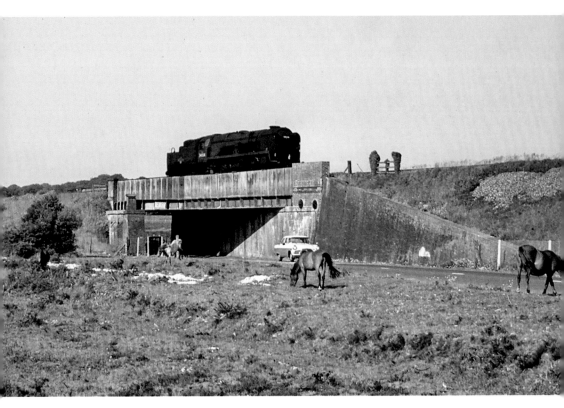

WC No. 34004 *Yeovil* runs light engine towards Brockenhurst to work the school train to Bournemouth on the afternoon of 14 June 1967. New Forest ponies graze and yet another Ford car passes; this one looks like a Zephyr.

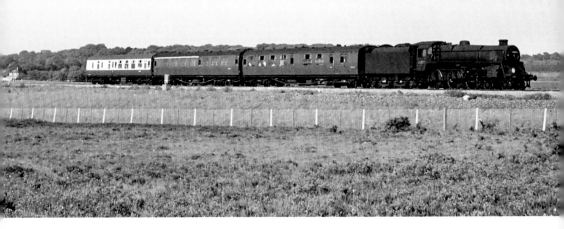

Std 4 No. 75077 climbs Sway Bank on 14 June 1967 with a stopping train from Southampton to Bournemouth.

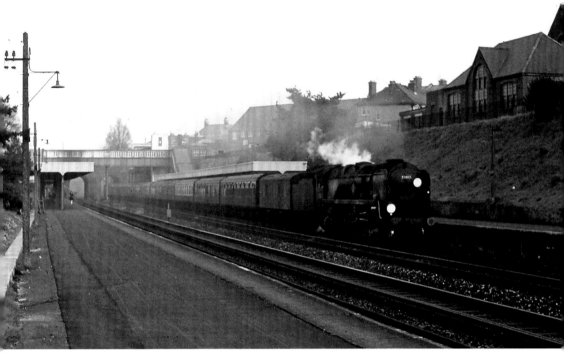

MN No. 35013 *Blue Funnel* arrives and departs from Pokesdown station in October 1966 with the 13.30 from Waterloo.

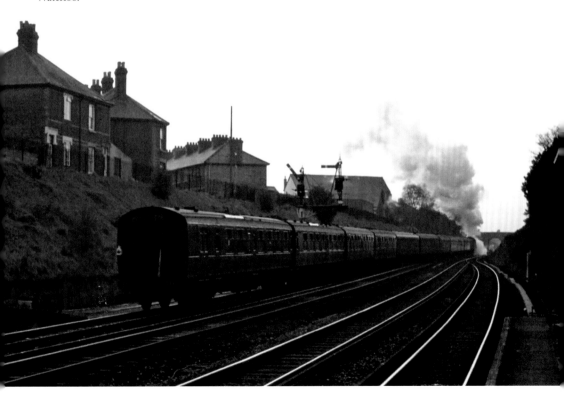

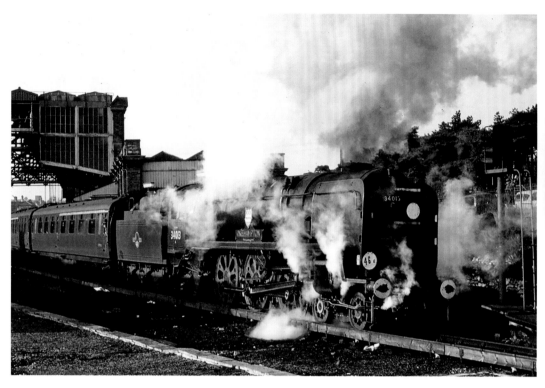

The cleaners at Salisbury have been busy, and WC No. 34013 *Oakhampton* looks in fine fettle as it leaves Bournemouth for Waterloo in August 1966.

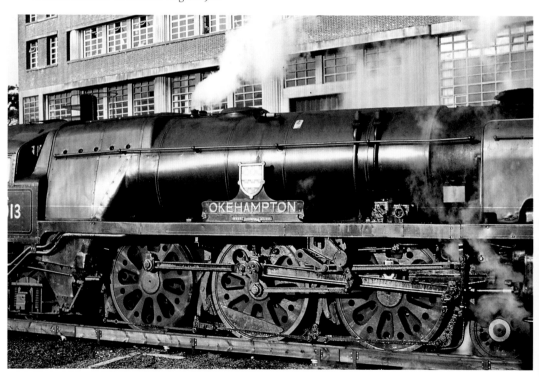

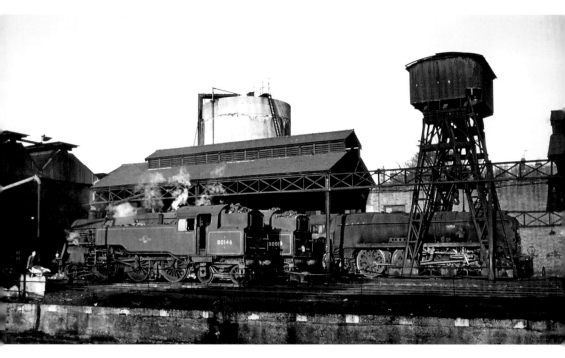

Std 4s Nos 80146 and 80019 and WC No. 34044 *Woolacombe* are on Bournemouth MPD, which was conveniently situated right next to the station. Taken in August 1966.

Std 4 No. 76067 and WC No. 34018 *Axminster* are being prepared for their next duties at Bournemouth MPD on 11 December 1966.

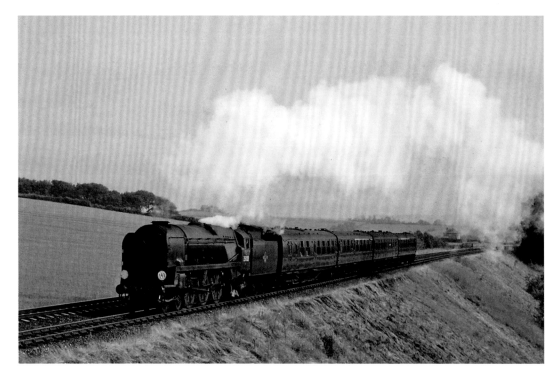

MN No. 35008 *Orient Line* climbs out of Weymouth and passes through the long-closed Upwey Wishing Well Halt and heads towards Bincombe South Tunnel (56 yards) with a local train to Bournemouth on 6 July 1967.

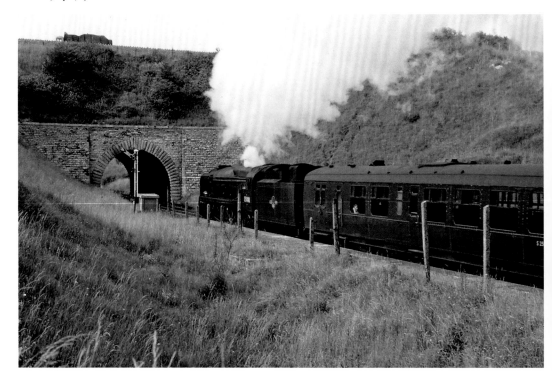

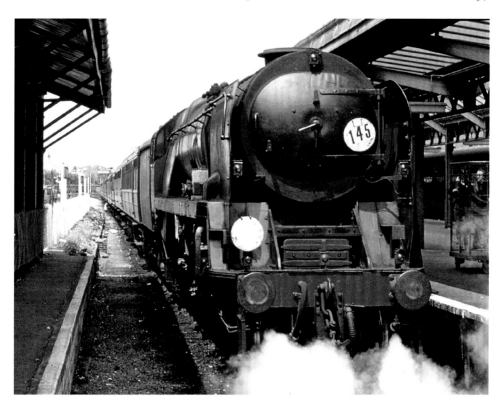

MN No. 35008 *Orient Line* has just arrived at Weymouth station with the 08.35 from Waterloo on 6 July 1967.

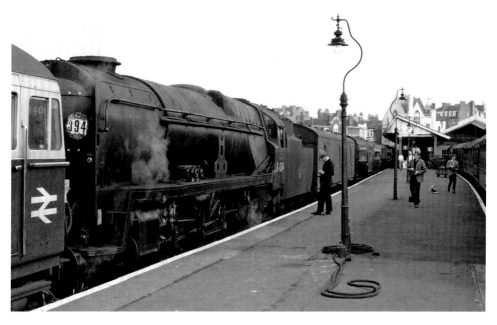

WC No. 34004 *Yeovil* waits to leave Weymouth with the 17.30 to Waterloo on 6 July 1967. A Class 33 diesel assisted us as far as Dorchester. This was my last steam-hauled journey into Waterloo.

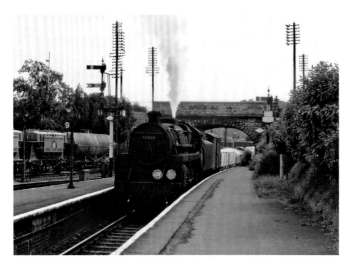

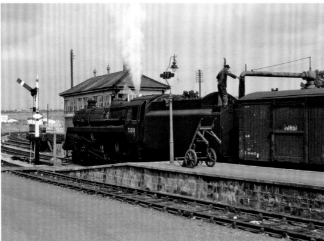

Std 5 No. 73018 arrives and stops to take water at Yeovil Pen Mill station on 6 July 1967 with the 14.45 freight from Weymouth to Westbury.

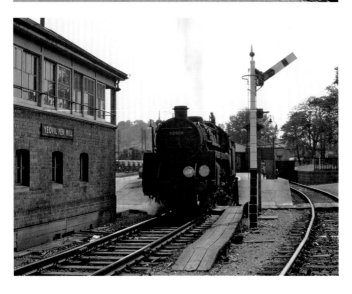

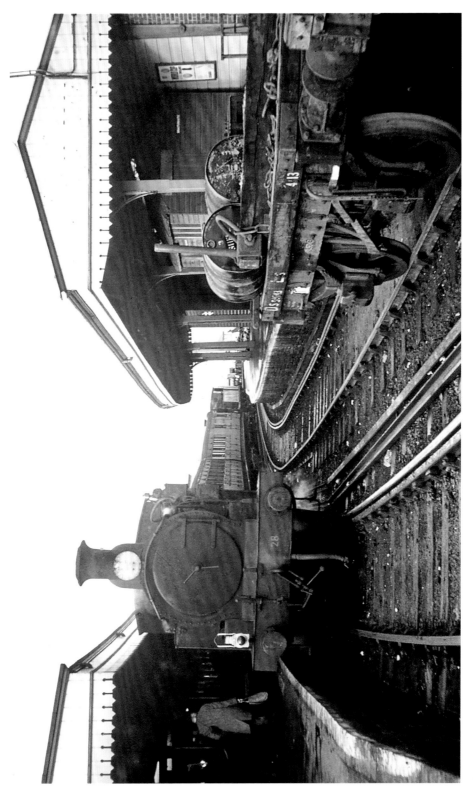

On the Isle of Wight, No. W28 *Ashey* waits to leave Ryde Esplanade station on 28 December 1966 with a train to Shanklin. W31 *Chale* is on the rear.

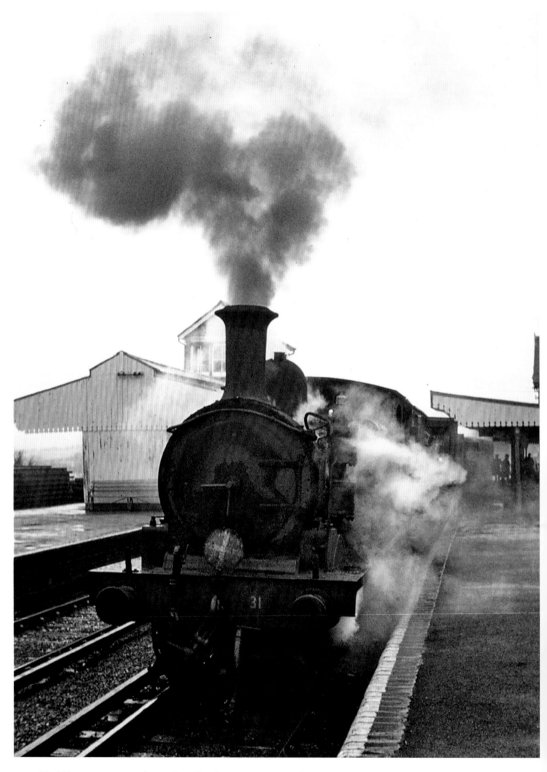

No. W31 *Chale* waits to depart from Sandown station on 28 December 1966 with a train for Shanklin.

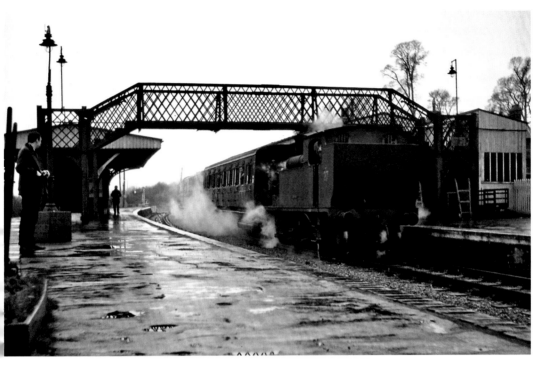

No. W27 *Merstone* is ready to depart from Brading station on 28 December 1966 with a Ryde train.

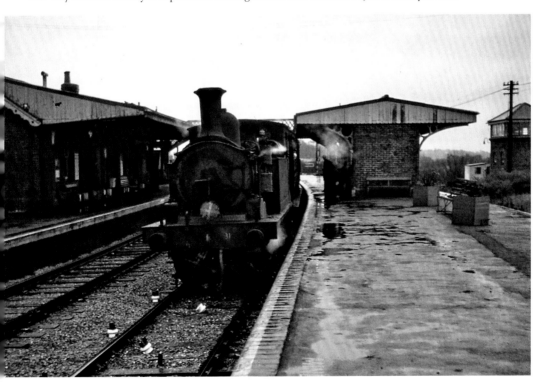

No. W31 *Chale* waits at Brading station on 28 December 1966 with a Shanklin service.

The following eleven pictures were taken on 31 December 1966 – the last day of steam-hauled services on the island. The line was then closed for three months to allow third-rail electrification to be installed.

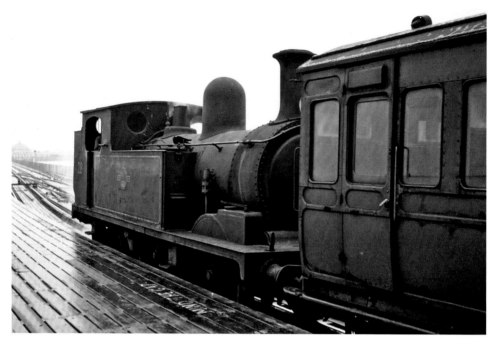

No. W28 *Ashey* has just arrived at Ryde Esplanade station with a train from Shanklin.

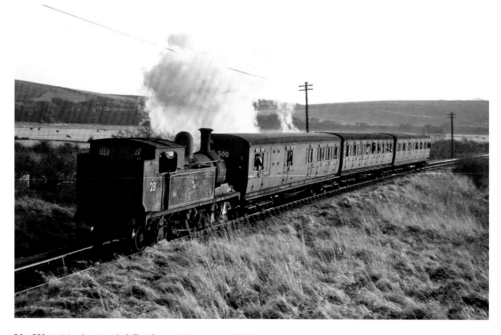

No. W28 *Ashey* has just left Brading with a train to Ryde.

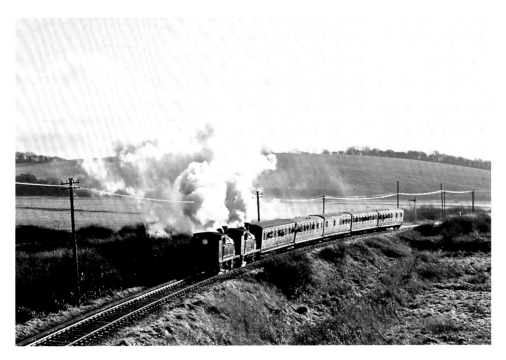

No. W24 *Calbourne* and W31 *Chale* have just left Brading with the LCGB Last Day of Steam Special for Ryde.

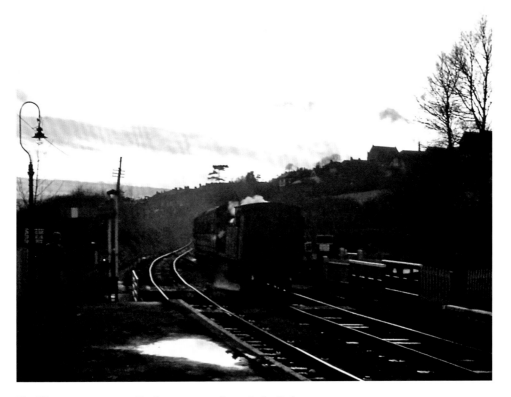

No. W17 *Seaview* arrives at Brading station with a train for Ryde.

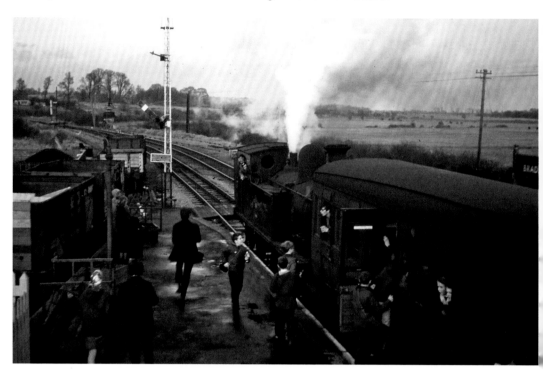

Passengers at Brading look for space on the last daylight service to Ryde. No. W17 *Seaview* seems to have a crowded footplate as well.

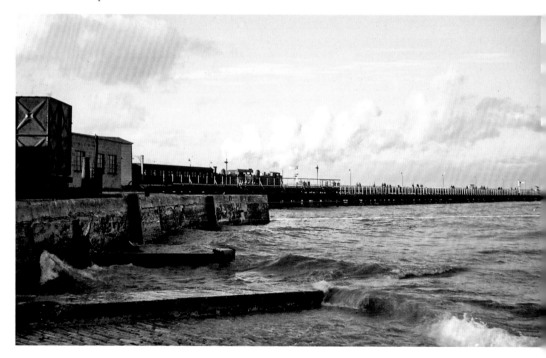

No. W24 *Calbourne* and No. W31 *Chale* propel the empty stock of the LCGB special away from Ryde Esplanade station.

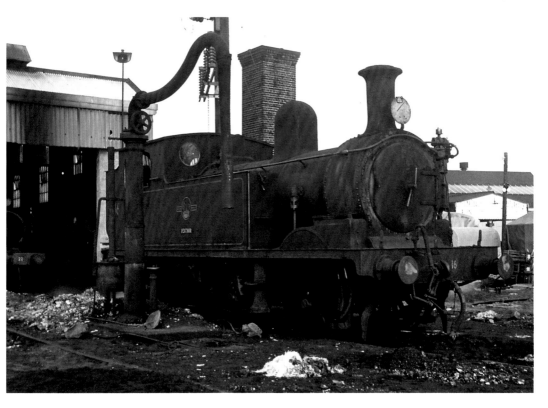

No. W16 *Ventnor* stands outside Ryde MPD.

No. W16 *Ventnor* and No. W17 *Seaview*, waiting for duty outside Ryde MPD.

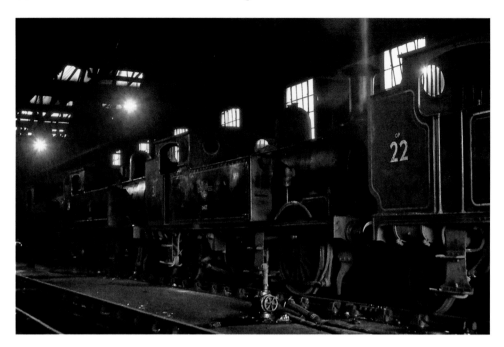

No. W27 *Merstone*, No. W24 *Calbourne*, No. W31 *Chale* and No. W22 *Brading* are inside Ryde MPD and have all made their last journeys, except for No. W24, which will be preserved on the Isle of Wight Steam Railway.

No. W24 *Calbourne*, No. W31 *Chale*, No. W22 *Brading* are inside Ryde MPD, while No. W17 *Seaview* stands outside, and No. W28 *Ashey* passes with a Ryde to Shanklin train.

*Above*: No. W16 *Ventnor* and No. W17 *Seaview* face the sunset at Ryde MPD.

*Right*: WC No. 34013 *Oakhampton* has just arrived at Preston Park station on 20 February 1966 with the SCTS Southdown Venturer Railtour from London Victoria.

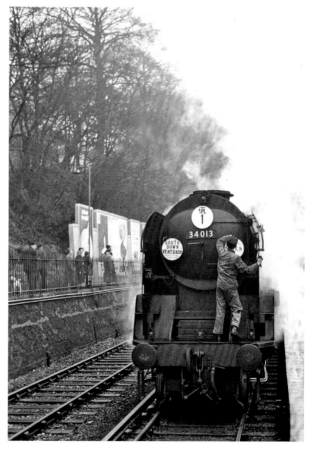

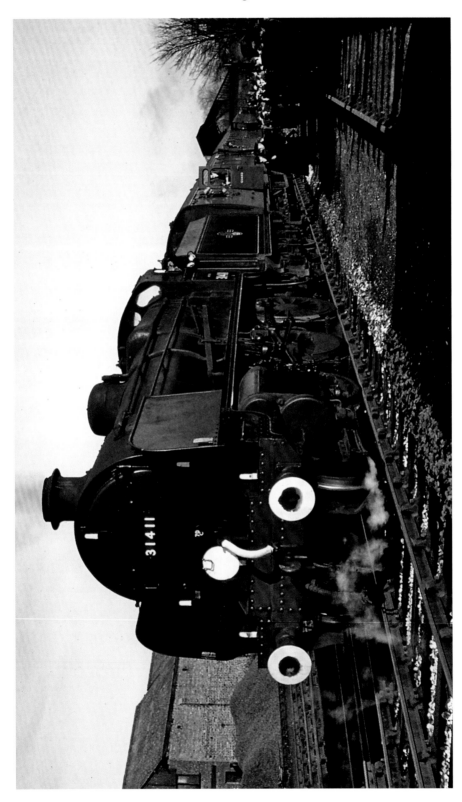

N Class No. 31411 waits to leave Gosport station with the tour on 20 February 1966. Gosport station had closed to passengers in 1953, but remained open to freight traffic until 1969.

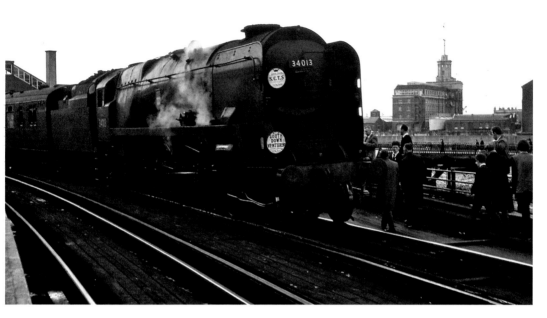

WC No. 34013 *Oakhampton* waits to depart from Portsmouth Harbour station on 20 February 1966 for the return journey to London Bridge station.

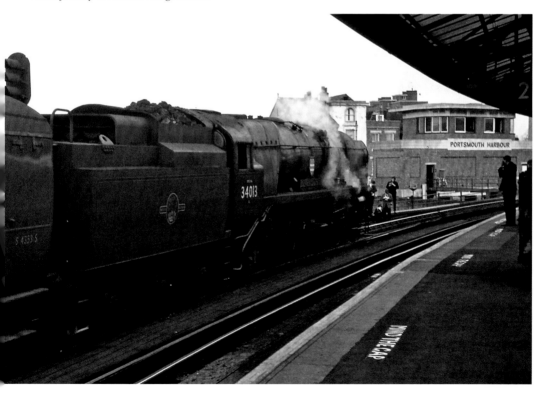

The next five pictures were taken on the LCGB Somerset & Dorset Railtour, which ran on 5 April 1966. The Somerset & Dorset Line from Bath to Bournemouth and the branch line from Evercreech Junction to Highbridge were to close the next day and this would be one of the last trains to run over this very popular and much-missed line.

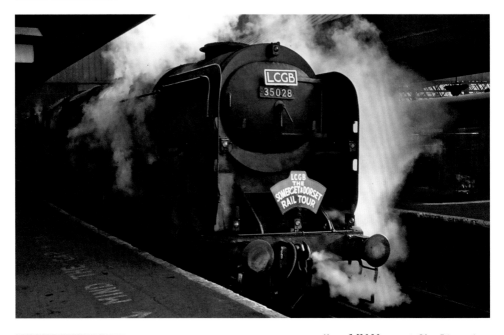

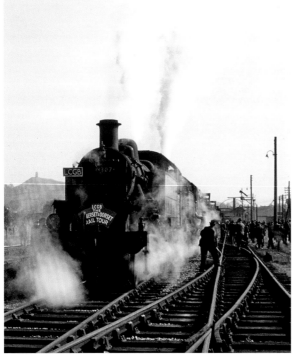

*Above*: MN No. 35028 *Clan Line* waits to leave Waterloo station with the tour.

*Left*: Ivatt Class 2s Nos 41307 and 41249 pause at Glastonbury for a photo stop. In the background, Glastonbury Tor can be seen on top of the hill.

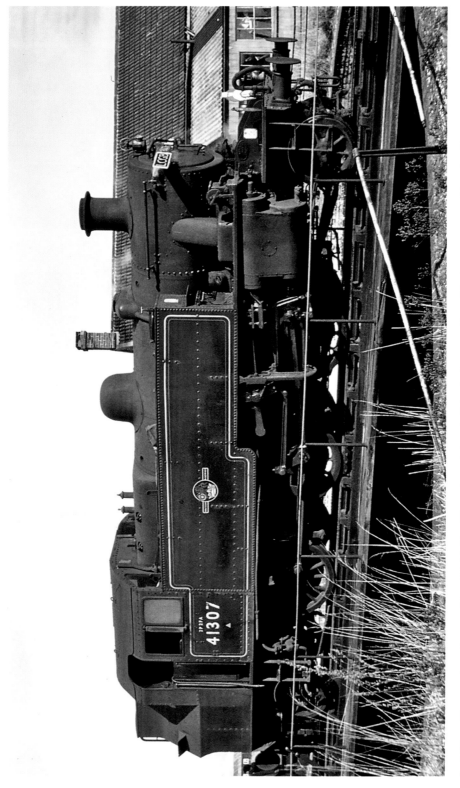

Ivatt Class 2 No. 41307 is on the turntable at Highbridge. The main workshops built by the Somerset Central Railway were situated here, handling major repairs and building a small number of locos before being closed in 1930.

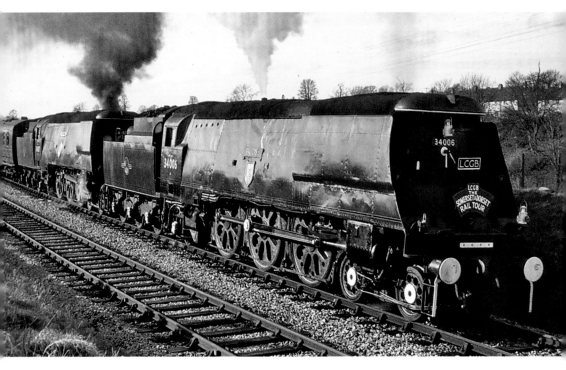

WC No. 34006 *Bude* and BB No. 34057 *Biggin Hill* stop at Chilcompton station for photos.

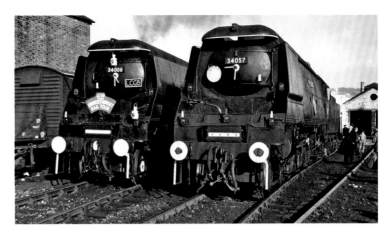

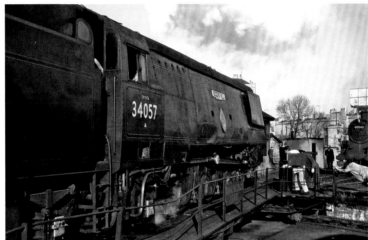

WC No. 34006 *Bude* and BB No. 34057 *Biggin Hill* at Bath Green Park MPD. The locos have been turned, have taken water, and the crews are making final preparations for the return journey to Bournemouth.

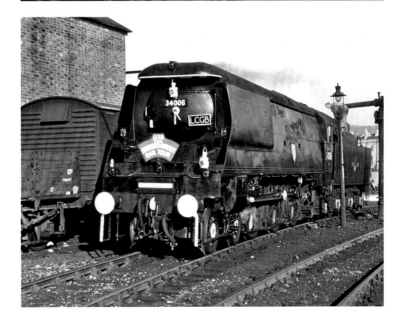

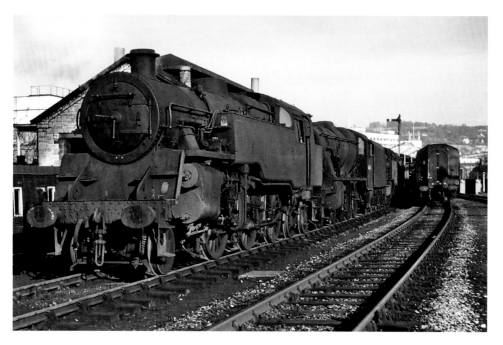

Std 4 No. 80039, 8F No. 48444 and Ivatt 2 No. 41291 are dumped alongside the shed at Bath Green Park MPD. No. 80039 and No. 48444 will go to Cashmores at Newport for scrapping and No. 41291 will be cut up at Cohen's of Morriston.

The next six pictures were taken on the Locomotive Club of Great Britain New Forester Railtour, which ran on 19 March 1966.

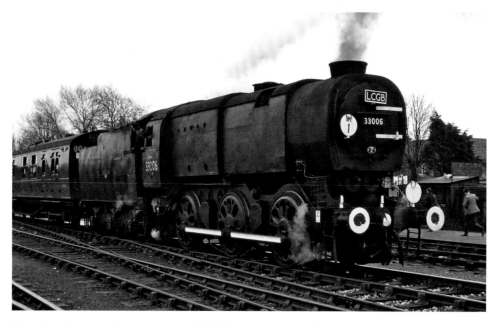

The railtour is seen at Gosport station with Q1 No. 33006 in charge. Gosport was a popular stop for railtours as it was at the end of one of the few remaining branch lines in the area.

USA Class Nos 30064 and 30073 are waiting to leave Southampton Terminus station, which closed on 5 September 1966. Passengers for sailings from the adjacent docks used this station for many years. The Cunard liner *Queen Elizabeth* can be seen between the buildings in the third picture.

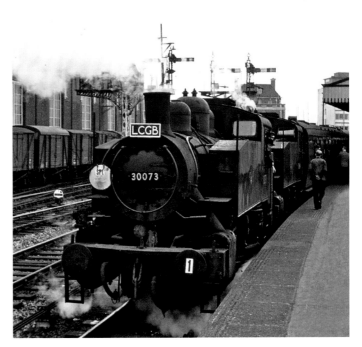

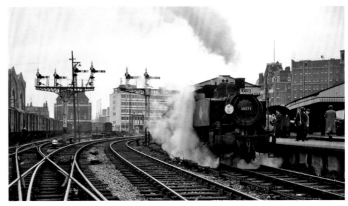

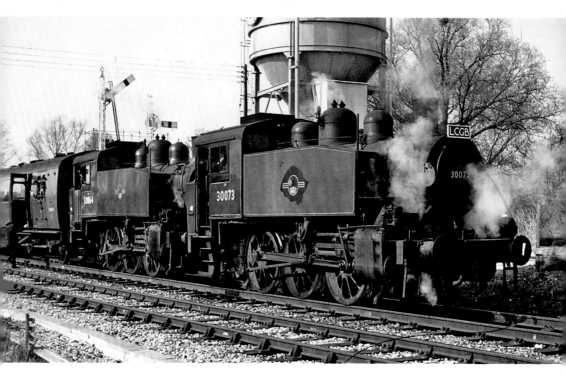

USA Class Nos 30073 and 30064 are at Marchwood for a photo stop. The train is on the Fawley branch, which served the oil refinery and the Marchwood Military Port on the Solent.

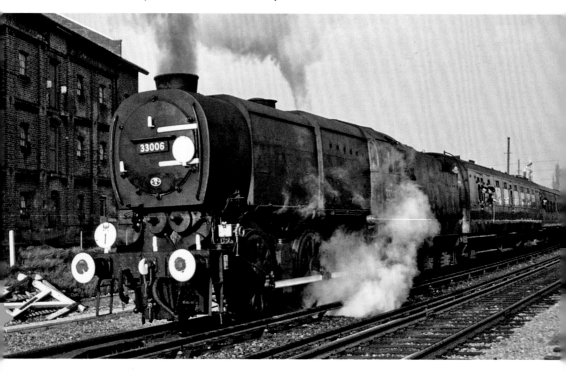

Q1 No. 33006 waits to leave Totton for the final leg of the tour to Lymington and Brockenhurst.

The next eight pictures were take on the LCGB Wilts & Hants Railtour, which took place on 3 April 1966.

N Class No. 31411 and U Class No. 31639 wait for departure from Guildford station.

Nos 31639 and 31411 stop at the former Great Western Mortimer station for photographs.

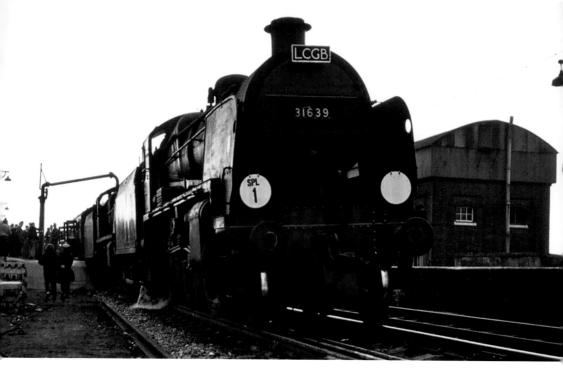

Nos 31639 and 31411 are taking water at Basingstoke station.

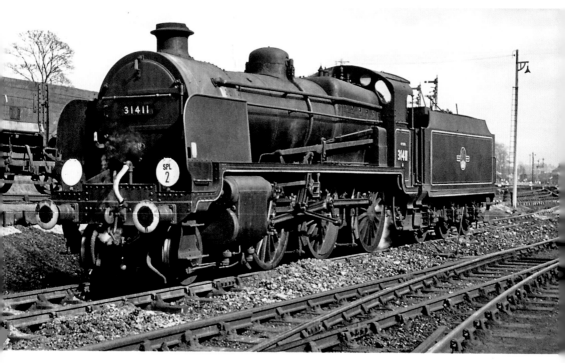

No. 31411 is seen in the yard at Salisbury MPD.

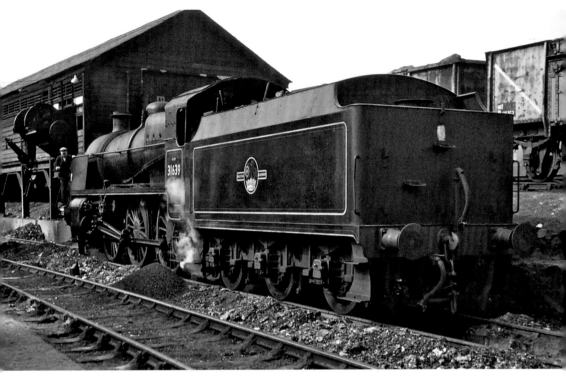

No. 31639 is made ready for the next part of our tour at Salisbury MPD.

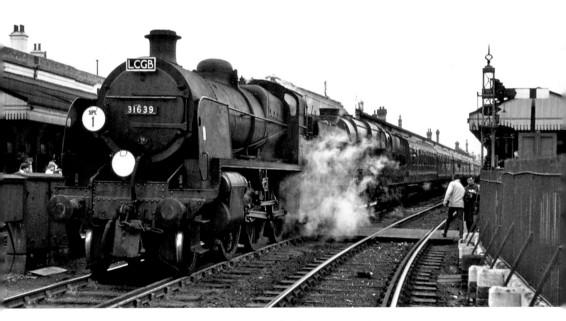

U Class No. 31639 and Q1 No. 33006 are ready to leave Salisbury station with the tour.

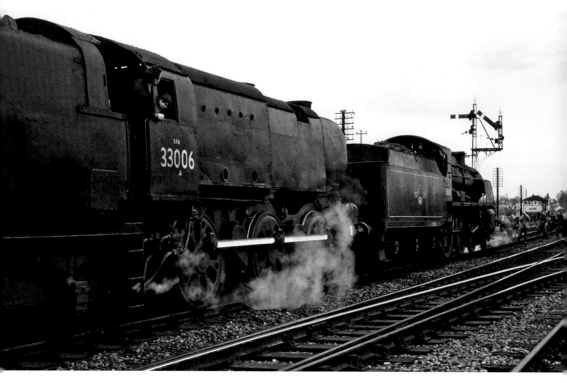

Nos 31639 and 33006 are waiting to leave Romsey station for Waterloo.

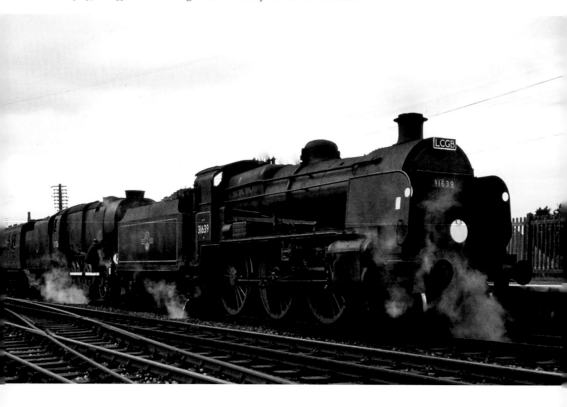

No. 33006 and No. 31639 have arrived at Waterloo station nine minutes early. This is believed to have been the last journey made by a Q1.

The next six pictures were taken of the Railway Correspondence & Travel Society's 'Longmoor' Special train, which ran on 30 April 1966.

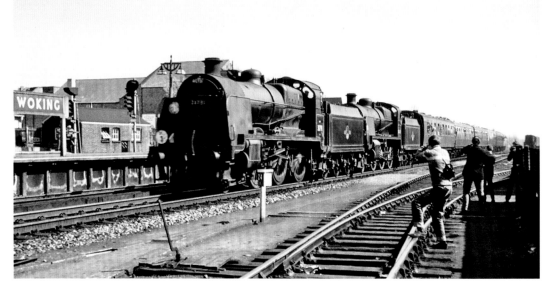

U Class No. 31791 and No. 31639 arrive at Woking station with the tour.

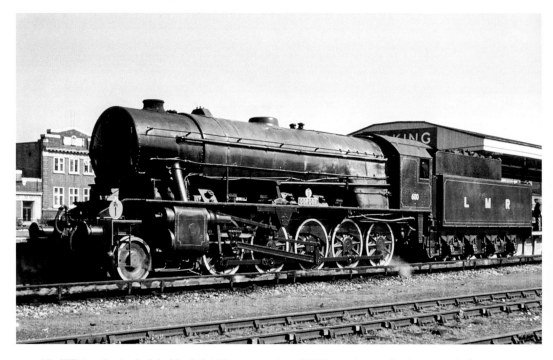

No. WD600 *Gordon*, built by North British in 1943, waits at Woking station to take the tour to the Longmoor Military Railway. This loco is preserved at the Severn Valley Railway.

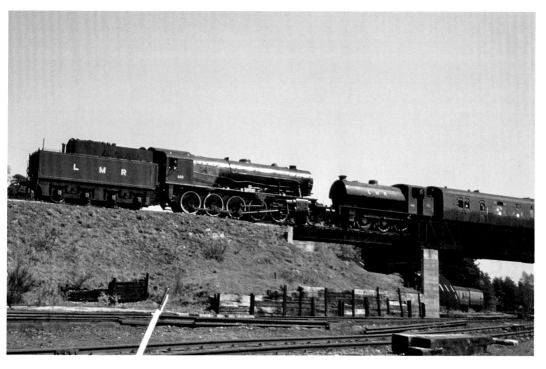

Nos WD600 and WD195 arrive at the Military Railway Longmoor Depot with the tour.

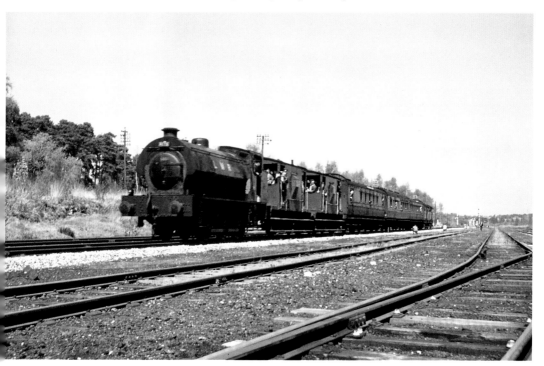

No. WD196 heads a trainload of enthusiasts on a tour of the Military Railway, which at one point had some seventy miles of track.

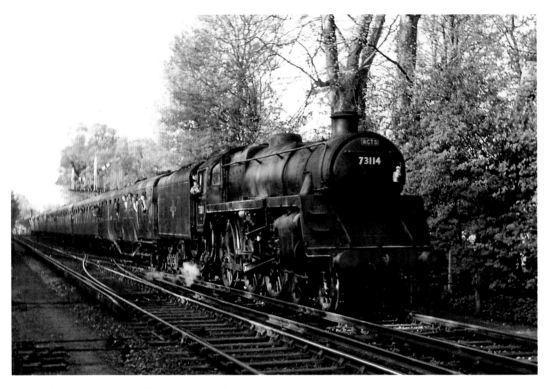

Std 5 No. 73114 arrives at Windsor & Eton Riverside station with the tour.

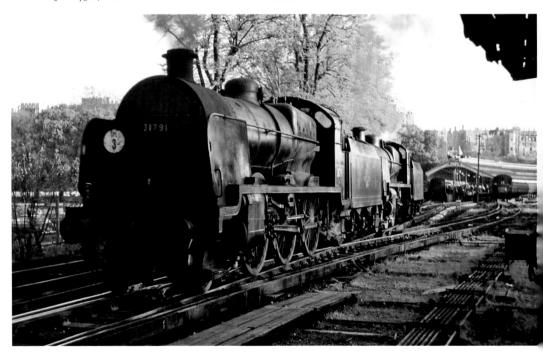

Nos 31791 and 31639 are at Windsor & Eton Riverside station prior to taking the special on the last part of the journey to Waterloo.

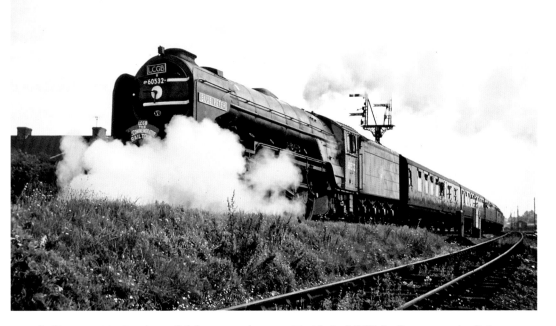

A2 No. 60532 *Blue Peter* leaves Salisbury on 14 August 1966 with the LCGB A2 Commemorative Railtour. The loco had come all the way from Scotland, but was unfortunately not in very good condition and the special ran very late.

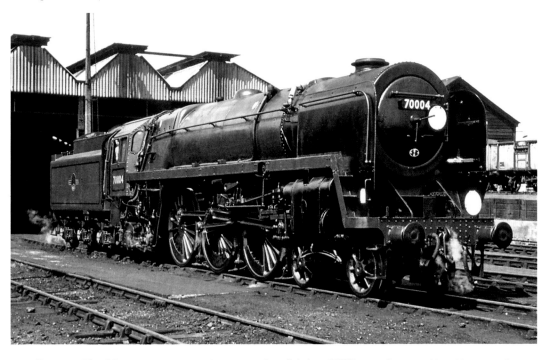

Britannia Class No. 70004 *William Shakespeare* stands at Salisbury MPD on 14 August 1966, waiting to work the A2 special back to Waterloo.

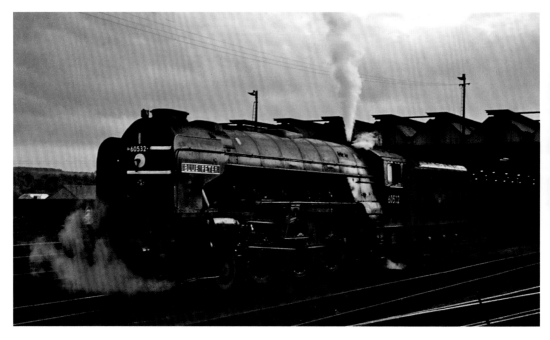

A2 No. 60532 *Blue Peter* at Salisbury MPD on 14 August 1966 is awaiting some repairs before it makes its way back to Scotland.

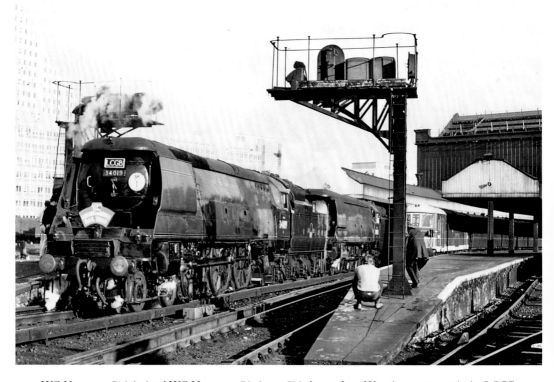

WC No. 34019 *Bideford* and WC No. 34023 *Blackmore Vale* depart from Waterloo station with the LCGB Dorset & Hants Railtour on 16 October 1966.

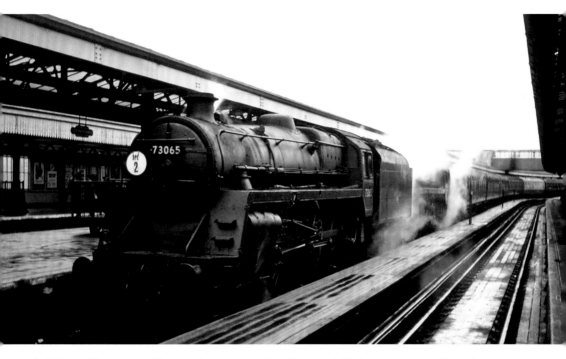

Std Class 5s No. 73065 and No. 73043 have just arrived at Portsmouth Harbour station on 31 December 1966 with the LCGB Isle of Wight Farewell Railtour.

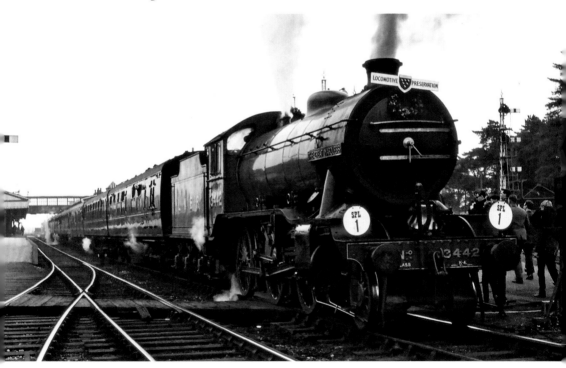

No. 3442 *The Great Marquess* takes water at Fareham station on 12 March 1967 while working the Locomotive Preservation (Sussex) Ltd Special, The Marquess Goes South.

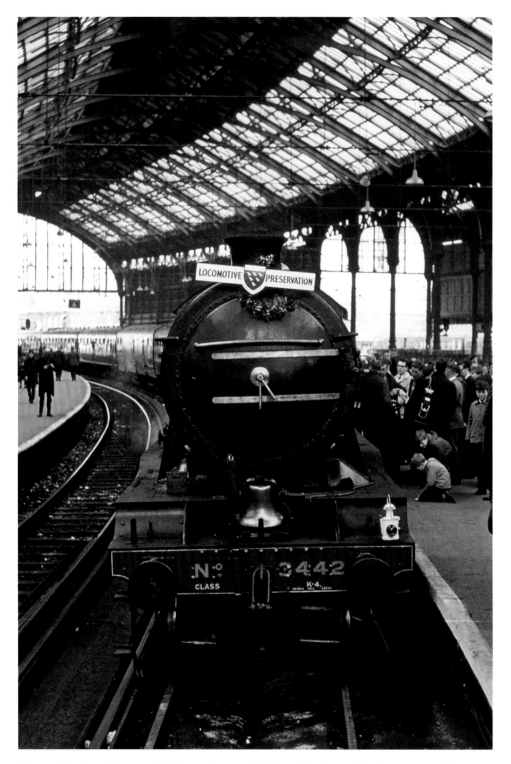

No. 3442 *The Great Marquess* at Brighton station on 12 March 1967 before working the next part of the tour to Chichester.

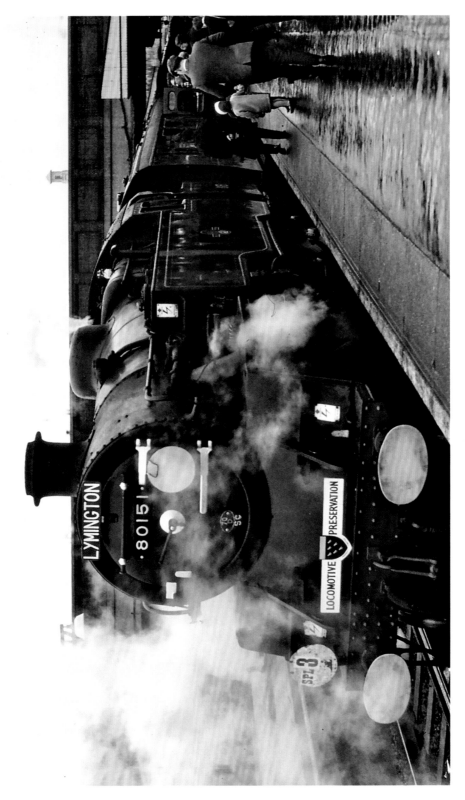

Std 4 No. 80151 is seen at Southampton Central station on 12 March 1967 before heading the special to Lymington Pier.

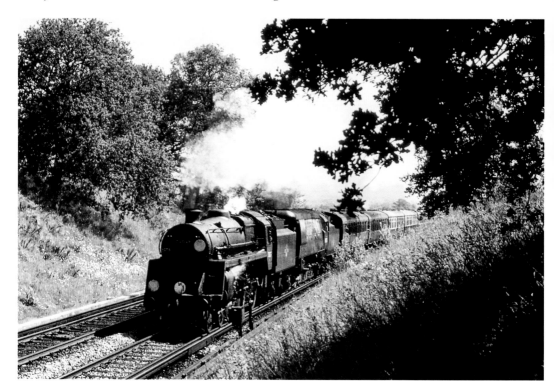

Std 5 No. 73029 and WC No. 34023 *Blackmore Vale* near Haslemere on 18 June 1967 with the RCTS Farewell to Southern Steam Tour.

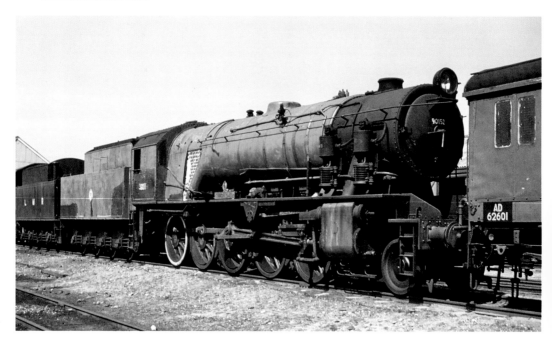

2-10-0 No. WD601 *Kitchener* at Longmoor MPD on 30 April 1966. No. WD601 was built in 1945 by North British (NB) and was scrapped in 1967.

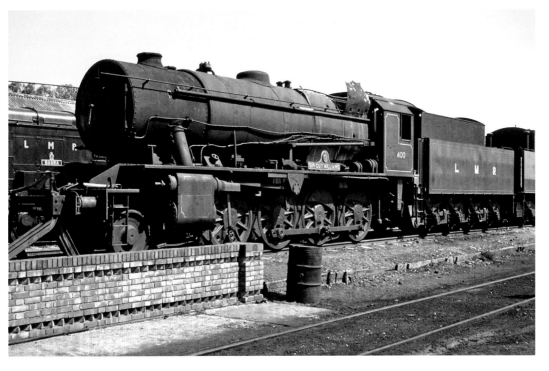

2-8-0 No. WD400 *Sir Guy Williams* at Longmoor MPD on 30 April 1966. No. WD400 was built by NB in 1943 and scrapped in 1967.

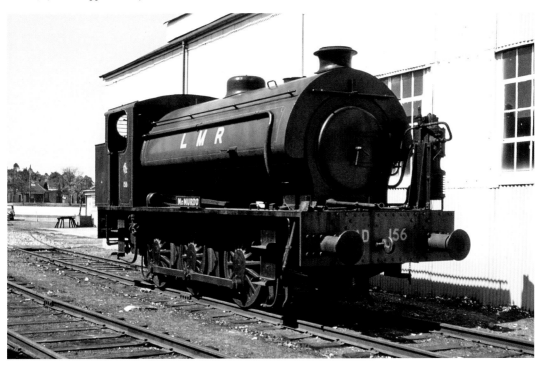

No. WD156 *Torbruk*, built by Hunslet, at Longmoor MPD on 30 April 1966.

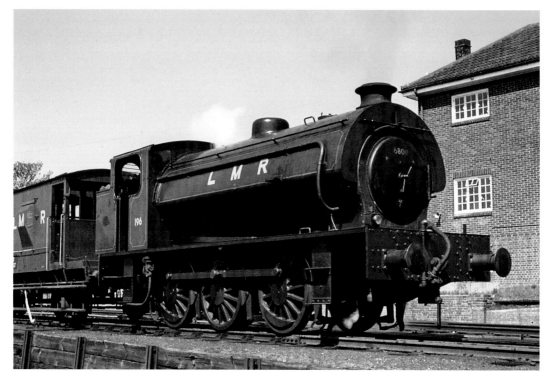

No. WD196 *Errol Lonsdale*, built by Hunslet, at Longmoor MPD on 30 April 1966.

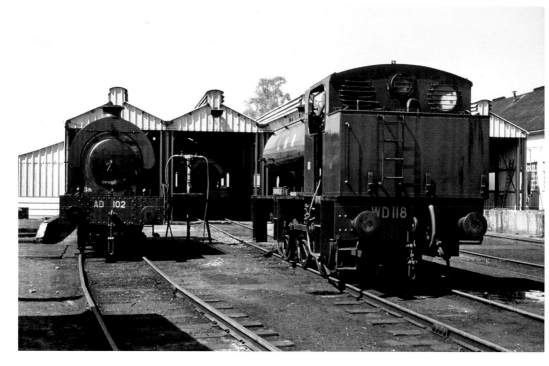

No. AD102 and No. WD118 *Brussels*, built by Hudswell Clarke in 1945, at Longmoor MPD on 30 April 1966.

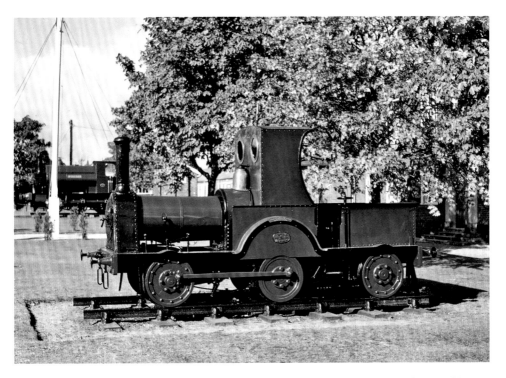

0-4-2 *Gazelle* was built by Dodman of Kings Lynn in 1893 and is now preserved at the Colonel Stephens Museum in Tenterden. Picture taken while the loco was at the Longmoor military Railway on 28 September 1968.

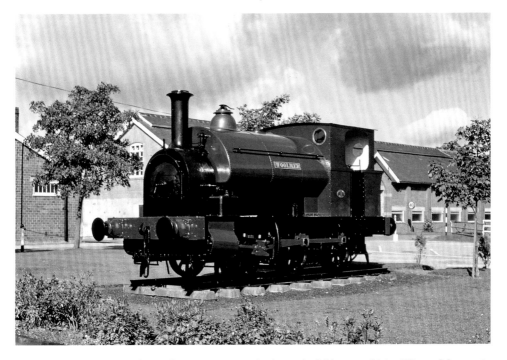

0-6-0ST *Woolmer*, built by Avonside in 1910, now on display at the Milestones Living History Museum in Hampshire. Picture taken at Longmoor 28 September 1968.

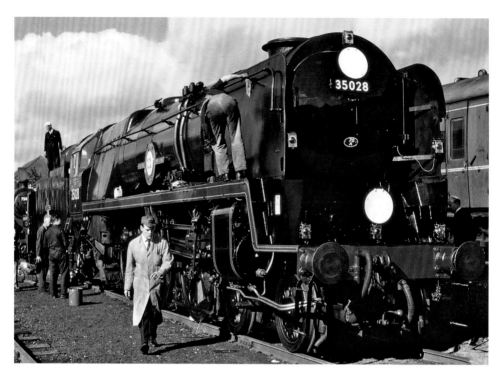

MN No. 35028 *Clan Line* undergoing restoration by the Merchant Navy Preservation Society at Longmoor on 28 September 1968.

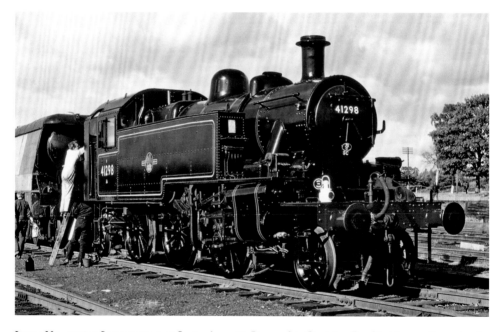

Ivatt 2 No. 41298 at Longmoor on 28 September 1968. It moved to Quainton Road but in 2014 it went to the Isle of Wight Railway, where it was returned to working order for the first time since 1967. Behind No. 41298 is WC No. 34023 *Blackmore Vale*, which had been purchased recently from BR and has been returned to working order on the Bluebell Railway.

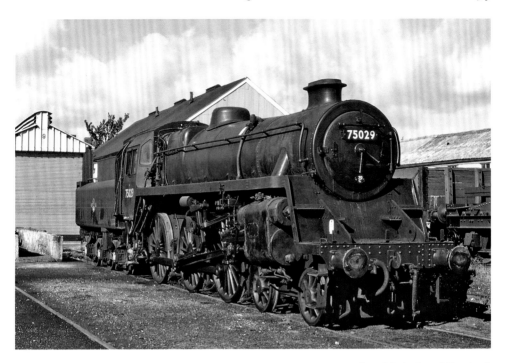

Std 4 No. 75029 at Longmoor on 28 September 1968 after being purchased from BR by David Shepherd. No. 75029 would later be named *The Green Knight*.

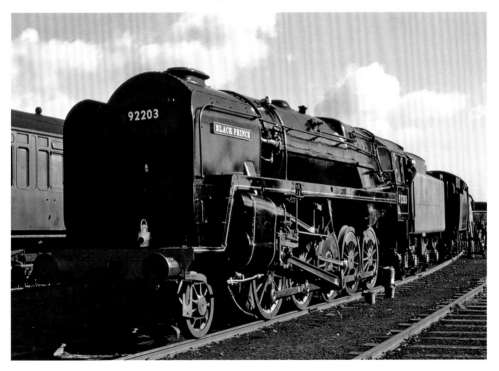

9F No. 92203, at Longmoor on 28 September 1968, was also purchased from BR by David Shepherd, and would later be named *Black Prince*.

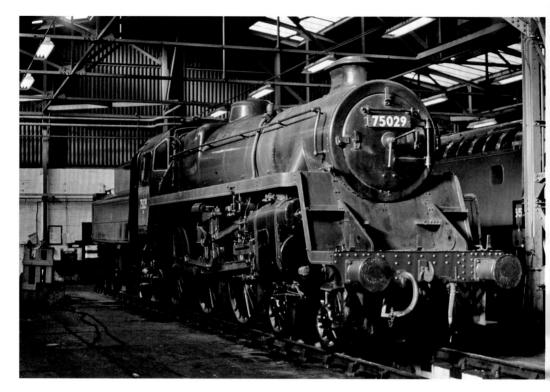

Std 4 No. 75029, seen here at Eastleigh MPD on 12 March 1972 after the closure of the Longmoor Centre. It later moved to the East Somerset Railway.

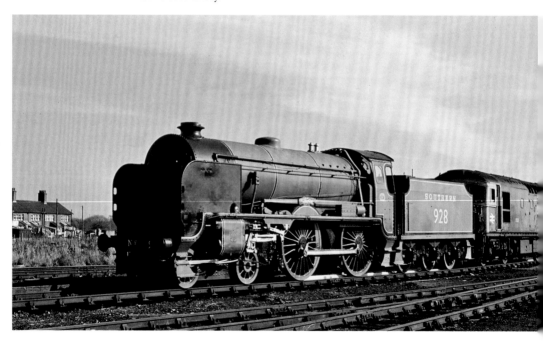

Schools Class 928 *Stowe* at Eastleigh MPD on 12 March 1972. This loco was purchased from BR by Lord Montague in 1964 for exhibition at Beaulieu, but from 1973 worked on the East Somerset Railway.